ACKNOWLEDGMENTS

For their invaluable and generous assistance in loaning material from their collections, I wish to express my sincere gratitude to those individuals who helped me, in particular: Keith Cenedella; Larry Dunn; Luke DeNitto; Bill Flayer; Jerry Madsen; Susan J. Pack; Martin and Jilliana Ranicor-Breeze; Joe Urbanovitch, and Ian Whitcomb. With special thanks to Philip Collins; Lesley Bruynesteyn; Garry Brod; and to my wife, Isolde, for attending to the many production details of this book. Advertisements and brochures are reproduced courtesy of General Electric Company.

Printed in Hong Kong

ISBN 0-8118-0302-3

Library of Congress Cataloging in Publication Data available.

Book and cover design: Arnold Schwartzman
Photography: Copyright © 1993 Garry Brod
Composition: Set in Cheltenham Book
by Isolde Schwartzman

Distributed in Canada by
Raincoast Books
112 East Third Avenue
Vancouver, B.C. V5T 1C8

10 9 8 7 6 5 4 3 2

Chronicle Books
275 Fifth Street
San Francisco, California 94103

Phono-Graphics

THE VISUAL
PARAPHERNALIA OF
THE TALKING MACHINE

ARNOLD
SCHWARTZMAN

Photography by
GARRY BROD

CHRONICLE BOOKS SAN FRANCISCO

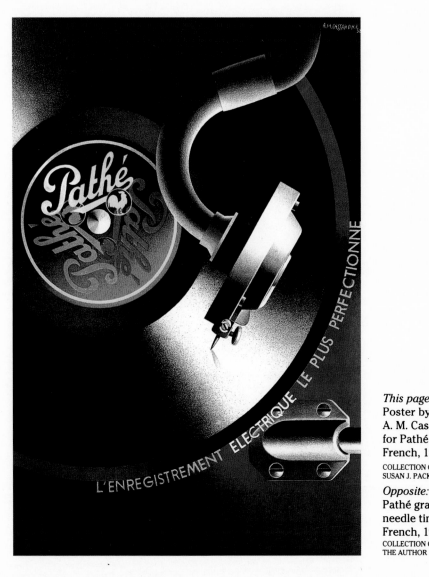

This page:
Poster by
A. M. Cassandra
for Pathé Disques.
French, 1932.
COLLECTION OF
SUSAN J. PACK

Opposite:
Pathé gramophone
needle tin,
French, 1920's.
COLLECTION OF
THE AUTHOR

For Isolde

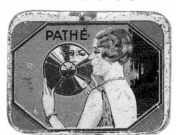

TABLE OF CONTENTS

TRADE MARK

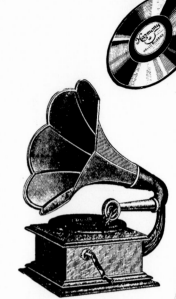

INTRODUCTION 8

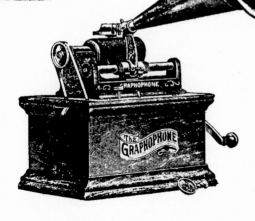

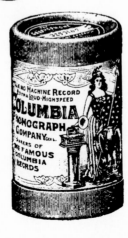

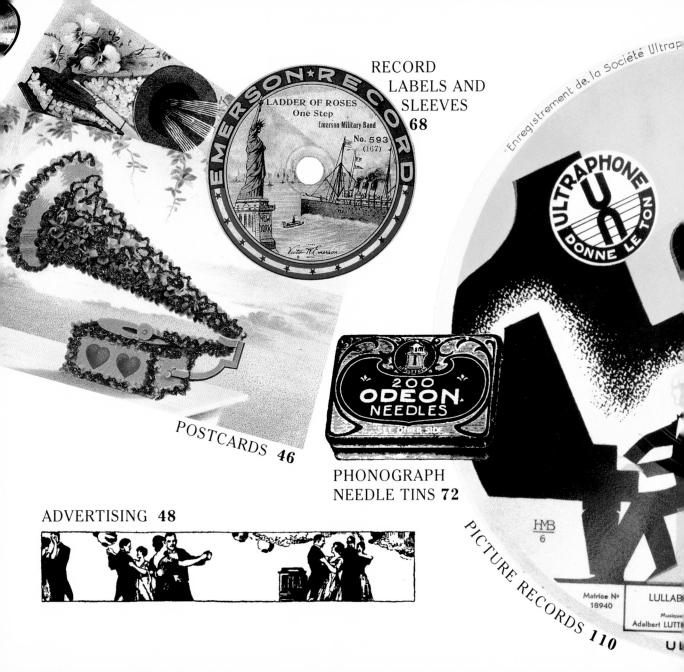

ictor and Victrola's trademark became synonymous with home entertainment at the turn of this century. Its visual identity and that of other talking machine companies produced a plethora of graphic images, from cylinder boxes, record labels, and advertising, to the designs on picture records and phonograph needle tins.

Out of my interest in the graphics that decorated these tins came a desire to seek other related items created for this medium. One day I secured an invitation to attend a meeting of The City of London Phonograph and Gramophone Society, founded in 1919. Their monthly meetings were held in a private room above The White Swan public house in the hub of London's newspaper district.

The Society's members were seated at small separate tables clutching pints of beer and facing the bar at the far end of the room where, beside a large horned phonograph, a life-size white plaster bust of the Society's "patron saint," Thomas Alva Edison, took pride of place. The Club Secretary confided to me that prior to each meeting he would give Mr. Edison a good scrub in his bath!

The evening's "recitalist" proudly produced a selection of phonograph cylinders out of a large well-worn suitcase, and proceeded to introduce each recording in minute detail: "This Blue Amberol cylinder was recorded in an Army Drill Hall in 1912", and so on. Every nuance of the recording technique was elaborated upon.

Halfway through the evening's program, the Society's Chairman addressed the membership with "housekeeping" announcements, followed by the Secretary, who gravely announced the passing of a fellow member and, as a mark of respect to the departed devotee, requested thirty seconds of silence. Due to the advanced age of the membership, this was a regular item on the agenda.

The end of the period of silence was broken by a nervous cough from the Secretary, who then proceeded to announce that the deceased's widow

now wished to sell the long-coveted collection of phonographs, cylinders, and hill–and–dale discs: "Would those members interested in purchasing any of these items please see me for the address and telephone number?", at which point there was a frantic scramble to the Secretary's table! Such is the passion for the Talking Machine.

From Caruso to Crosby, and from Melba to Madonna, the popularity of the medium has endured—a trend reflected in the enormous sums of money commanded by recording stars today, often surpassing the astronomical fees of the movie industry.

My earliest recollection of the talking machine is my grandparents' Chippendale-style consul gramophone, which stood in the parlor behind their

Emile Berliner, inventor of the gramophone, was a Jewish immigrant, as were my grandparents, whose local dealer's advertisement in the London Jewish Times, proclaimed in Yiddish: "Music is the finest language in the world."

boot repair shop in London's East End.

In those wind-up, pre-electric days, in order to muffle the sound my grandparents improvised by placing a *schmutter* (Yiddish for a piece of cloth) into the cabinet's built-in amplifying horn. Later models, such as the Victrola, had louvered doors to adjust the volume. Similar louvers were previously used at recording sessions, separating performers such as Enrico Caruso from their accompanying orchestras to create a balance in the sound.

Among my favorite recordings were "The Laughing Song," which was the number one novelty song of its time, and the World War I hit "It's A Long Way to Tipperary," which I still possess—although the fragile shellac disc is severely cracked.

I like to think that the sound emitting from my grandparents machine, sans *schmutter*, resonated through the walls, perhaps providing a source of musical inspiration to the young neighbor who became an international recording star: George Shearing.

"Mary had a little lamb...". These first recorded words spoken by Thomas Alva Edison on August 12, 1877, made history in heralding the age of the phonograph and preserving for future generations such voices as Sarah Bernhardt, Prime Minister Gladstone, Alfred Lord Tennyson, and Queen Victoria.

Similar to the early motion pictures, having no means of mass duplication prior to 1902, it was necessary to record each cylinder one at a time.

In Washington, D.C. on November 8, 1887, German immigrant Emile Berliner invented the first version of the disc gramophone. Not to be out-done by Edison's nursery rhyme, Berliner recorded: "Tvinkle, tvinkle little star, how I vonder vot you are."!

Berliner's agent, William Barry Owens,

was exhibiting his new gramophone at London's Thames-side Hotel Cecil, while next door at The Savoy, Guglielmo Marconi was perfecting his invention: the radio.

The term gramophone is still used in Great Britain, however in the United States the machine became generically known as the phonograph or Victrola— the trade name of the Victor Talking Machine Company. Berliner's invention became the most popular medium of its time, generating a profusion of related items, such as the phonograph disc and its variety

COPYRIGHT, 1905, NATIONAL PHONOGRAPH CO.

Invented in 1877 by Thom still controls and manufac

of label designs, first introduced in 1900. The disc's surface was sometimes illustrated to further endorse the record's theme.

The advertisements for the Talking

10

Machines and their discs often included endorsements by stars such as Maurice Chevalier, and illustrations by distinguished French artists such as A. M. Cassandra and Jean Carlu.

The phonograph cabinet became a part of the American home's furniture,

EDISON PHONOGRAPH
:on. It is one of Mr. Edison's favorite inventions. He
He is constantly at work developing and improving it.

and was available in a variety of styles, from Gothic and Tudor, to "pseudo-Jaco", William and Mary and Queen Anne, to the eighteenth-century classic style of cabinet makers such as Adam, Chippendale, Hepplewhite, and Sheraton. This invention spawned an enormous industry of related graphic ephemera.

The phonograph was the leading entertainment medium of its day, and its 78 rpm discs required expendable needles that were housed in colorful containers. A proliferation of designs, created by anonymous lithographers of the day, illustrated the wide variety of subject matter manufacturers employed to merchandise them.

The majority of the hinged tins are rectangular, and measure less than two inches across. There are, however, a variety of shapes and materials, such as tin pyramids and bells, bamboo or lacquered wooden boxes, and even a grand piano made of Bakelite. Usually holding two hundred needles, most containers carry the warning: "To be used once only", printed in gold on black paper.

Since it was the diameter and length of the needle that regulated the

volume, the tins were often color coded to denote soft, medium, loud, or extra-loud tone. The tins' designs reflect various periods of style, from the Art Nouveau age of Pagliacci to the Art Deco era of Pinocchio.

Though tin was usually the material of choice in the twenties, some of the containers were made of Bakelite. Often, the inside of the tin's lid was lined with a paper advertisement bearing the name and address of the retailer. But the tins also served as advertisements for the numerous record companies, such as Brunswick, Columbia, Decca, "His Master's Voice", Odeon, and Pathé.

Since British steel was proclaimed to be of the finest quality, the designs also frequently displayed patriotic motifs. It was not unusual for the "Union Jack", the name "Britannia", or the British bulldog to be used in the gramophone needle tins' design.

To compete, German manufacturers used the strategy of producing more elaborate and colorful designs, such as the popular dance steps of the day—

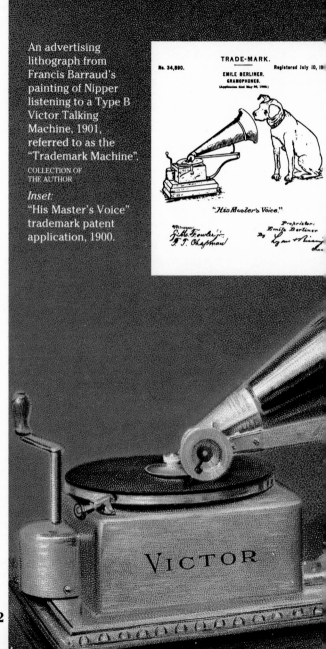

An advertising lithograph from Francis Barraud's painting of Nipper listening to a Type B Victor Talking Machine, 1901, referred to as the "Trademark Machine".
COLLECTION OF THE AUTHOR

Inset:
"His Master's Voice" trademark patent application, 1900.

12

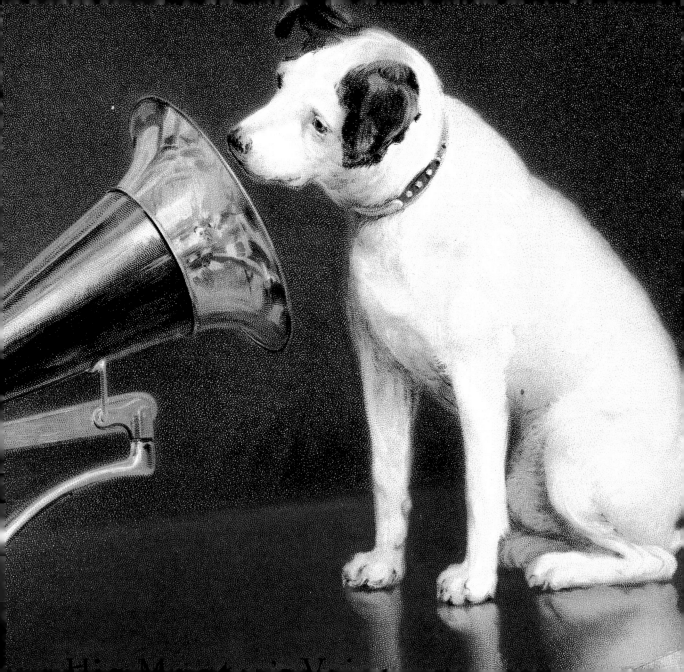

the fox trot, the tango, and the shimmy, others were adorned with historic figures, views of German cities, shadowgraphs, aeroplanes, submarines, or castles on the Rhine.

One of the world's most famous trademarks came about through sheer serendipity. On May 31,1899, the noted British portrait painter, Francis Barraud, called upon The Gramophone Company at their London headquarters in Maiden Lane, seeking to borrow an amplifying horn as a reference for his painting.

Upon being introduced to the company's General Manager, William Barry Owen, Barraud showed him the nearly completed painting of his brother's dog Nipper listening to a phonograph. Owen was most impressed with the painting. He agreed to the loan of the horn, and also offered to buy the painting when completed. The men agreed on the grand sum of one hundred pounds, including the copyright, providing Barraud substitute the existing phonograph cylinder machine in the painting with a Gramophone Company disc player.

As Barraud was leaving the show-room after delivering the completed painting, Owens called after him, enquiring whether the painting had a name. The artist's immediate response was: "His Master's Voice".

Plagiarisms of Francis Barraud's painting of Nipper listening to a horned gramophone abounded. Some versions show a dog and baby, a dog and radio, a dog and telephone, as well as a man in an armchair listening to "His Favourite Song".

Vintage containers are still to be found at swap meets and antique shops, particularly in the flea markets of Europe, sometimes virtually untouched, still wrapped in their

original paper seals just as they had come from the manufacturer, some eighty years ago.

By World War II, tins were replaced by paper packs, and finally, in 1948, the need to frequently change needles ceased with Peter Goldmark's invention of the vinyl microgroove LP, and its long-lasting stylus.

The advent of the long-playing record brought about the new artform of the album cover and cassette label, replacing the brown paper sleeve.

The arrival of radio and television broke the phonograph's monopoly of the public's attention. The steel needle has been replaced by the laser beam, and in its current digital CD incarnation, the recording industry enjoys a multi-billion dollar business.

This album of phonographic memorabilia will transport the reader on a nostalgic ramble over the hills and dales of a visual collectanea of the Talking Machine and its paraphernalia.

ARNOLD SCHWARTZMAN
Hollywood, 1993

Opposite: "His Master's Voice" decal, and a triangular German gramophone needle tin, 1920's.
This page: Le Disque Pathé record label, "Nostalgie", 1930's.
Right: Trademark for a French phonograph company, 1931.

PHONOGRAPHS AND CYLINDER BOXES

Thomas Alva Edison invented the phonograph in 1877, spawning an industry of Talking Machines and cylinders.

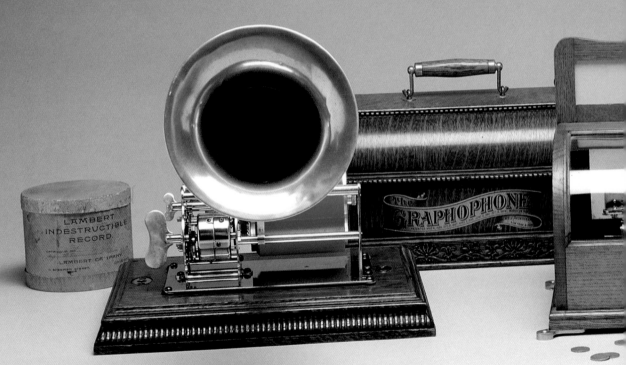

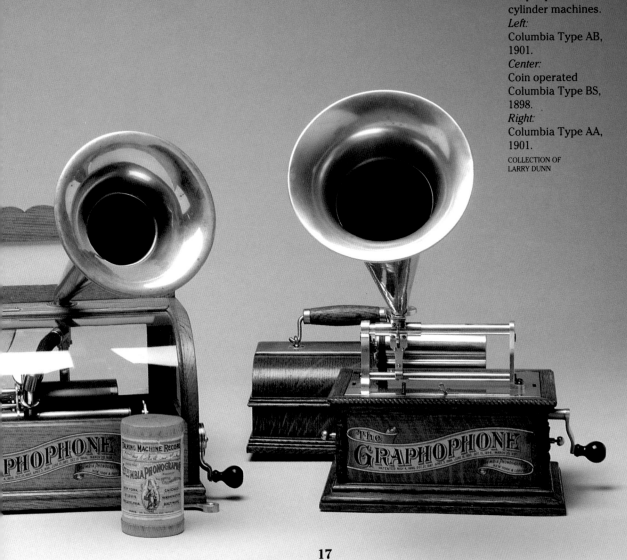

Three Columbia
Graphophone
cylinder machines.
Left:
Columbia Type AB,
1901.
Center:
Coin operated
Columbia Type BS,
1898.
Right:
Columbia Type AA,
1901.

COLLECTION OF
LARRY DUNN

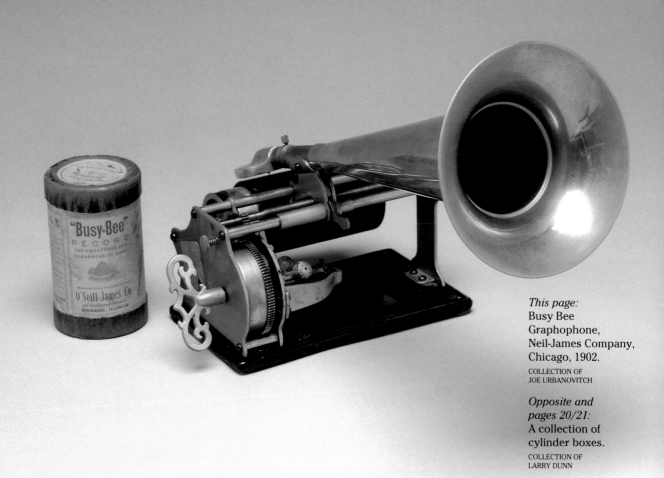

This page:
Busy Bee
Graphophone,
Neil-James Company,
Chicago, 1902.
COLLECTION OF
JOE URBANOVITCH

*Opposite and
pages 20/21:*
A collection of
cylinder boxes.
COLLECTION OF
LARRY DUNN

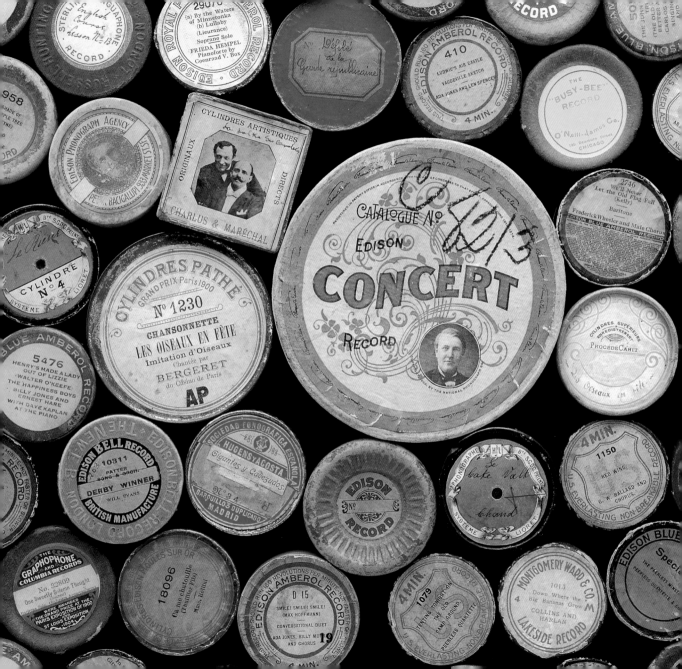

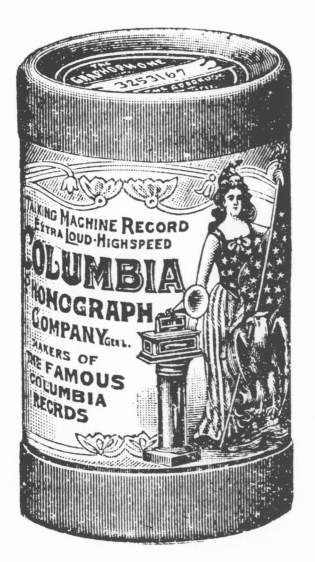

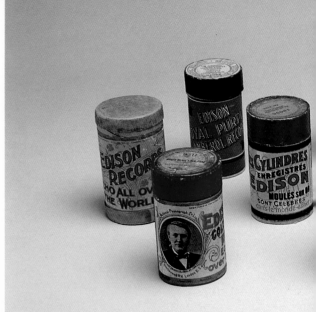

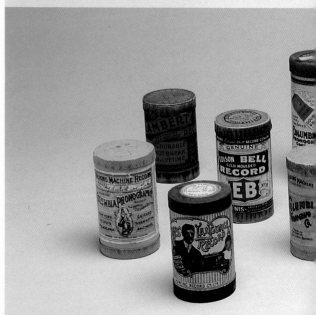

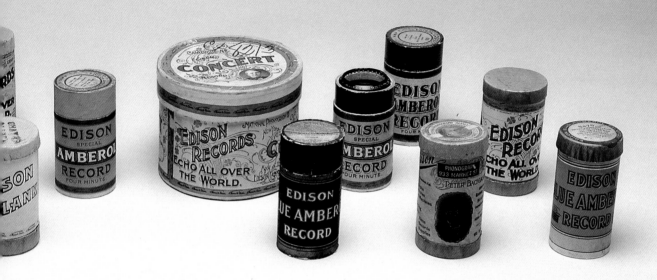
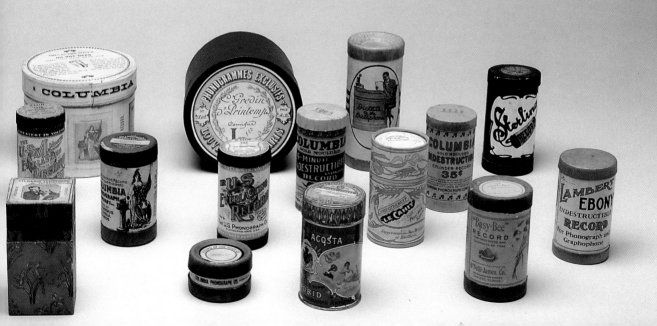

DISC PLAYERS

The invention of the disc playing gramophone by Emile Berliner in 1887 superseded Thomas Edison's phonograph and its cylinders.

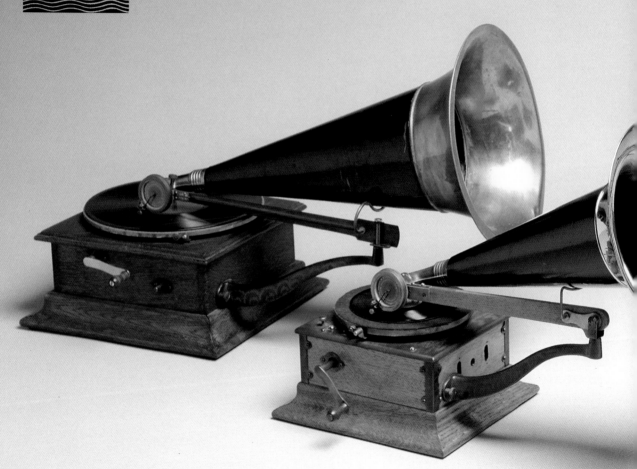

Three Victor
Talking Machines.
Left:
The Type P Victor
Premium, 1902–06.
This machine was
given away as a
premium with the
purchase of a
number of records.
Center:
The Victor Royal,
1902–04.
Right:
The Victor
Monarch Junior (E),
1902–05.

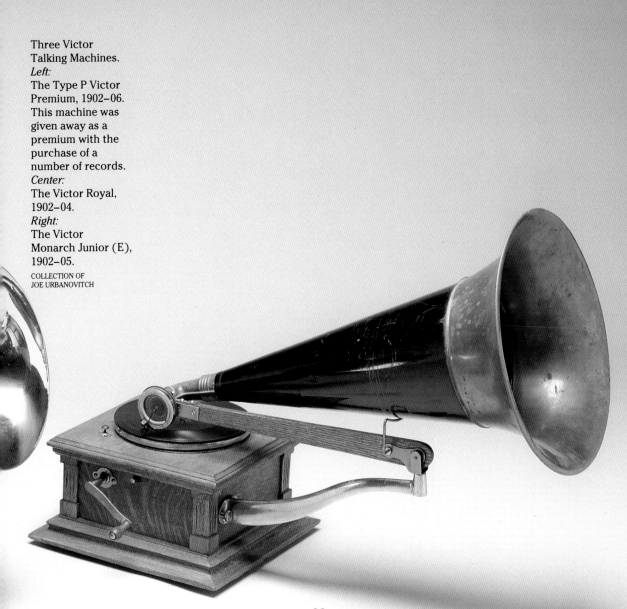

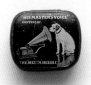

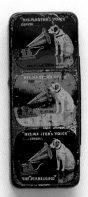

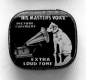
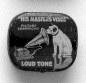

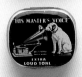
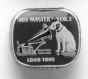

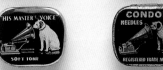

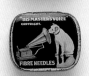

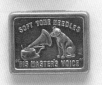

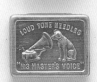

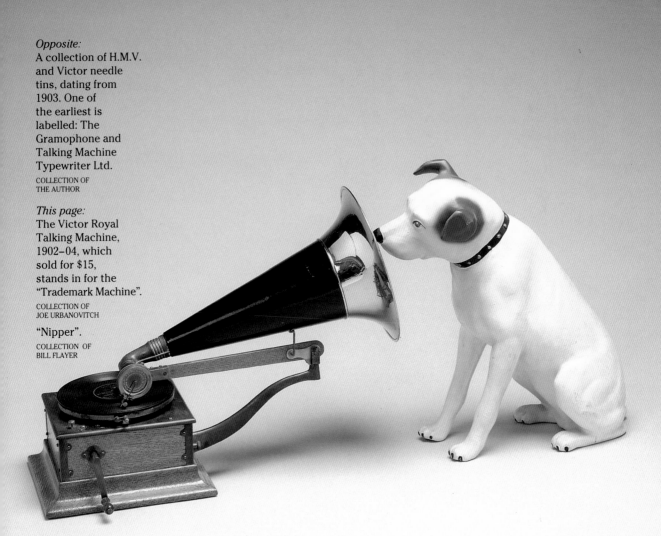

Opposite:
A collection of H.M.V. and Victor needle tins, dating from 1903. One of the earliest is labelled: The Gramophone and Talking Machine Typewriter Ltd.
COLLECTION OF
THE AUTHOR

This page:
The Victor Royal Talking Machine, 1902–04, which sold for $15, stands in for the "Trademark Machine".
COLLECTION OF
JOE URBANOVITCH

"Nipper".
COLLECTION OF
BILL FLAYER

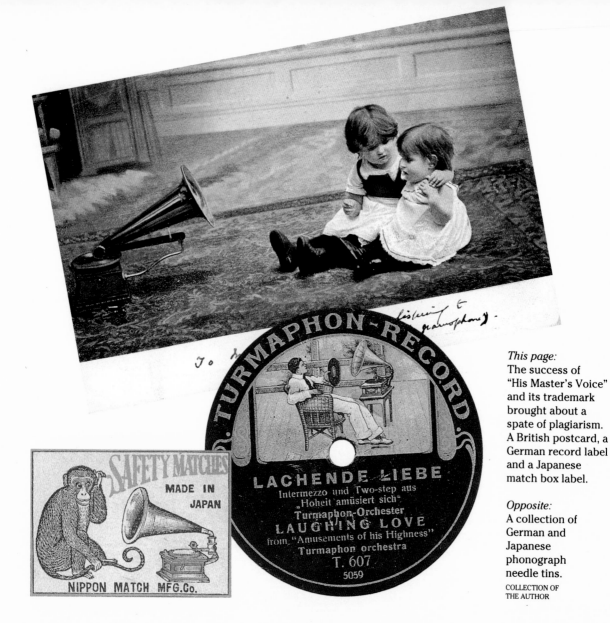

This page:
The success of
"His Master's Voice"
and its trademark
brought about a
spate of plagiarism.
A British postcard, a
German record label
and a Japanese
match box label.

Opposite:
A collection of
German and
Japanese
phonograph
needle tins.

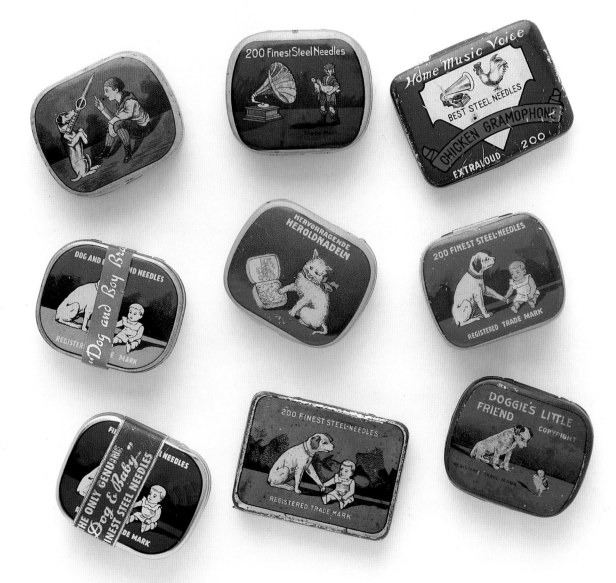

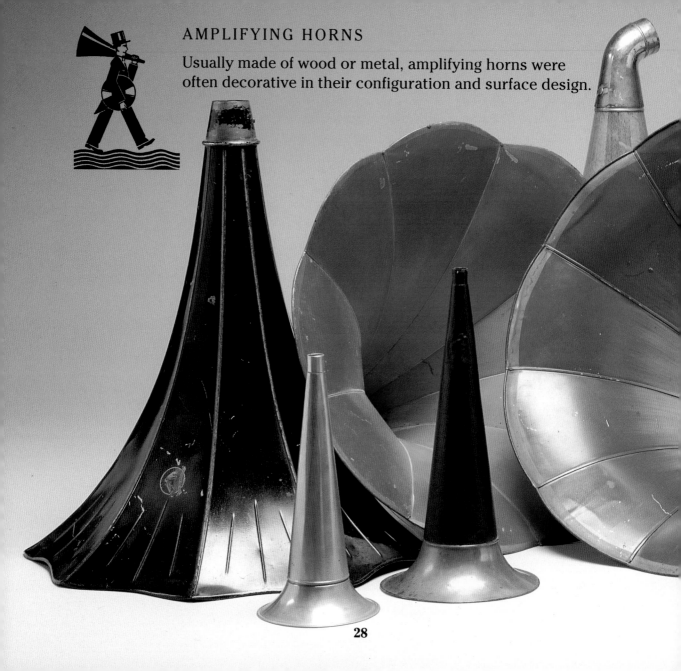

AMPLIFYING HORNS

Usually made of wood or metal, amplifying horns were often decorative in their configuration and surface design.

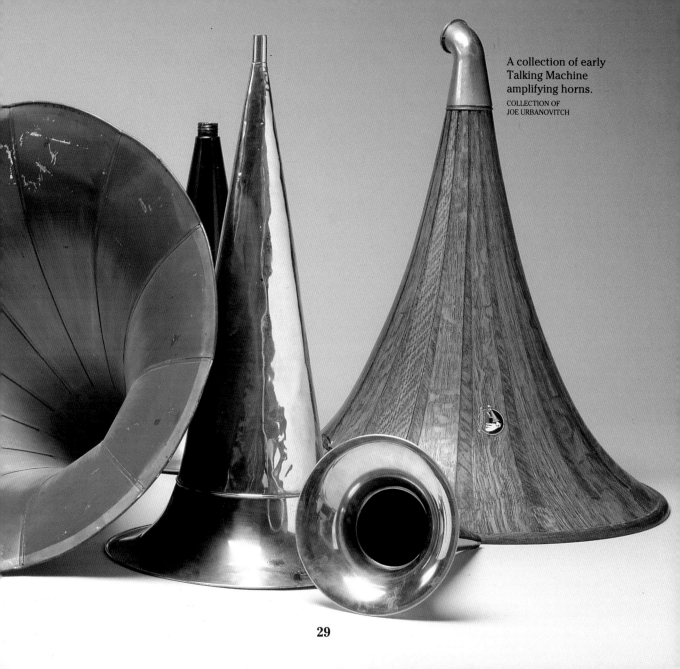

A collection of early
Talking Machine
amplifying horns.
COLLECTION OF
JOE URBANOVITCH

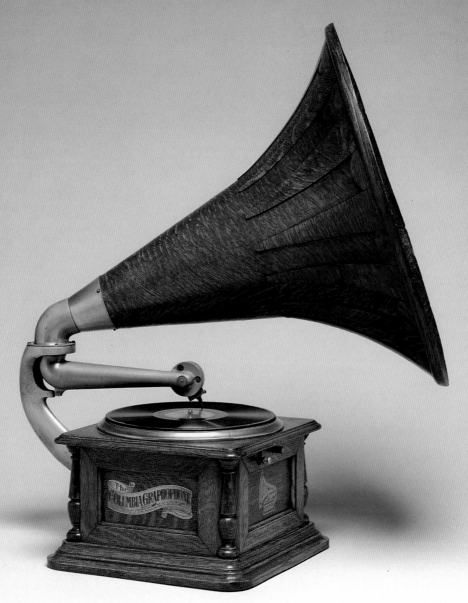

30

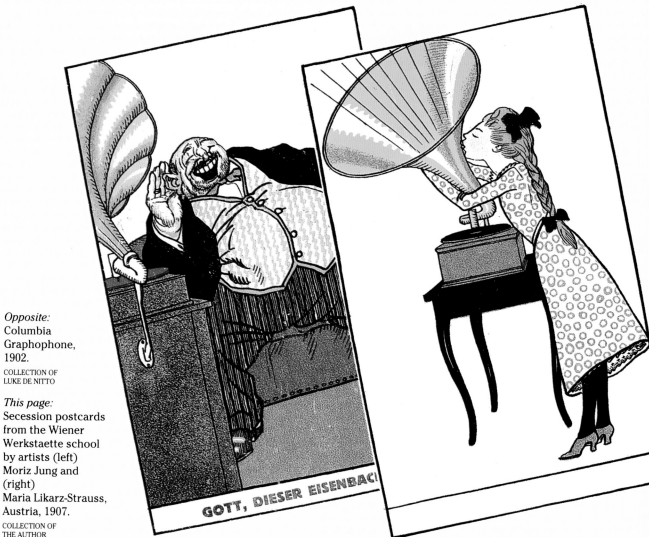

Opposite:
Columbia
Graphophone,
1902.
COLLECTION OF
LUKE DE NITTO

This page:
Secession postcards
from the Wiener
Werkstaette school
by artists (left)
Moriz Jung and
(right)
Maria Likarz-Strauss,
Austria, 1907.
COLLECTION OF
THE AUTHOR

GOTT, DIESER EISENBAC

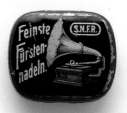
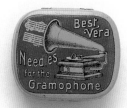
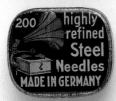
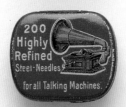
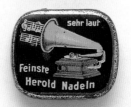
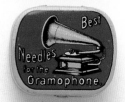
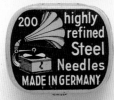
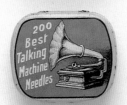
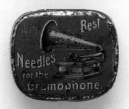
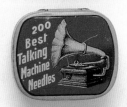
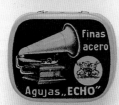
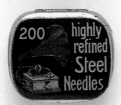

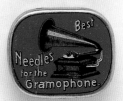

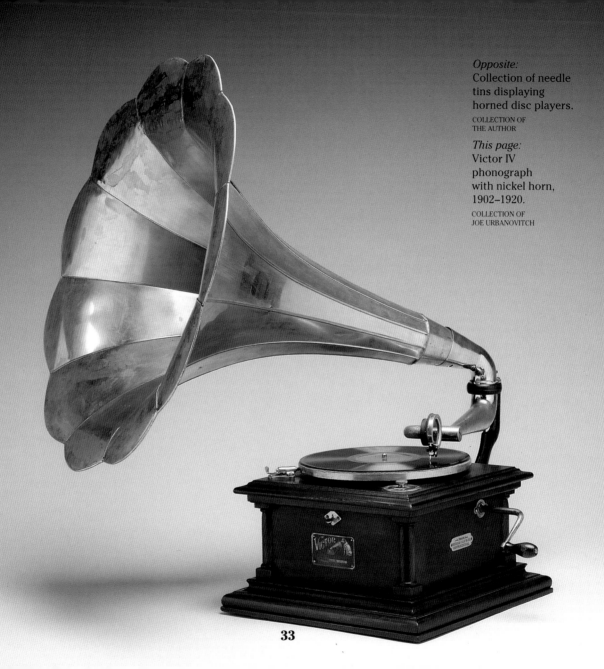

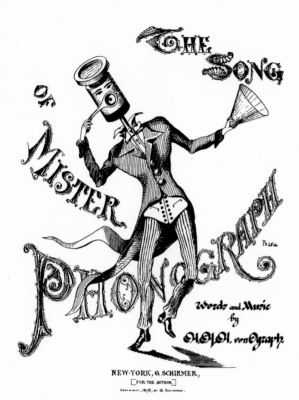

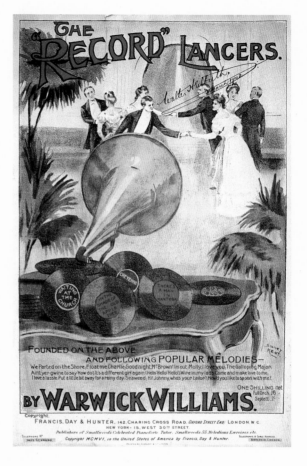

Music sheet cover:
"The Song of Mister
Phonograph", 1878.
"My name is Mister
Phono-graph and I'm
not so very old; My
Father he's called
E...dison, and I'm
worth my weight
in gold..."

Music sheet cover:
The "Record"
Lancers, 1906.

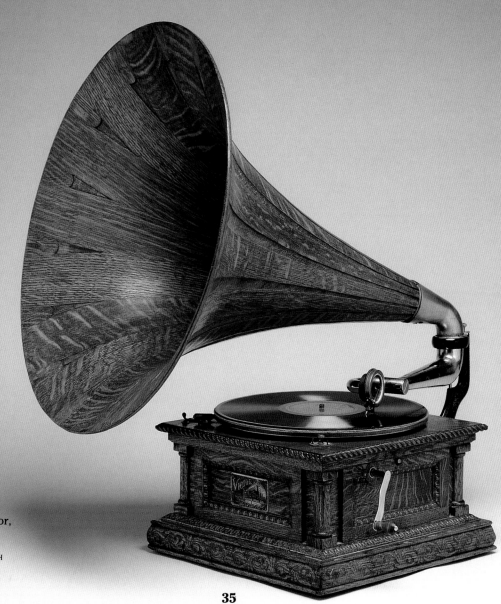

Type D Victor,
1903–1907.

Sousa's Band plays for *you*

and it plays music of your own choosing. The band of the great March King plays as many encores as you wish—such playing as is possible only when Victor records and Victrola instruments are used together. You can hear not only Sousa's Band, but Conway's Band, Pryor's Band, Vessella's Band, U. S. Marine Band, Garde Republicaine Band of France, Band of H. M. Coldstream Guards, Banda De Alabarderos — the greatest bands of every nation and the best music of all the kinds the whole world has to offer.

Victrolas $25 to $1500. New Victor Records demonstrated at all dealers in Victor products on the 1st of each month.

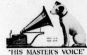

"HIS MASTER'S VOICE"

Victrola
REG. U. S. PAT OFF.

Important: Look for these trade-marks. Under the lid. On the label.
Victor Talking Machine Company, Camden, New Jersey

This page:
Victrola advertisement featuring John Philip Sousa.

Opposite:
The Victor Monarch Junior (E), 1904.
COLLECTION OF
BILL FLAYER

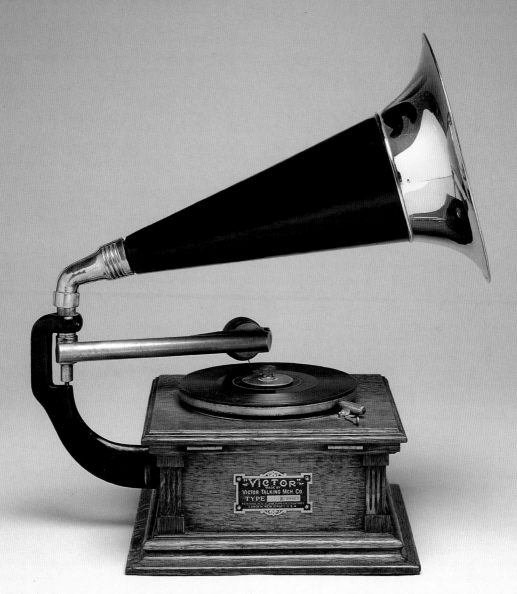

37

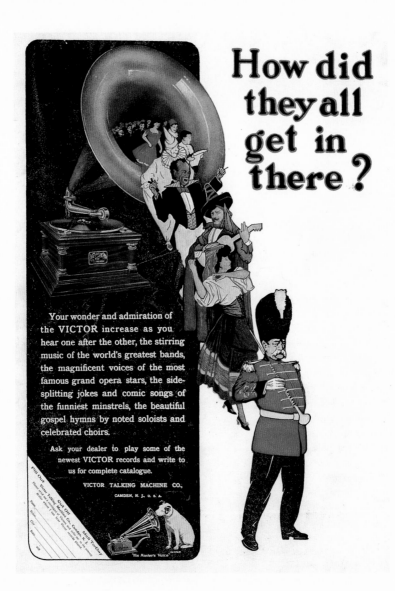

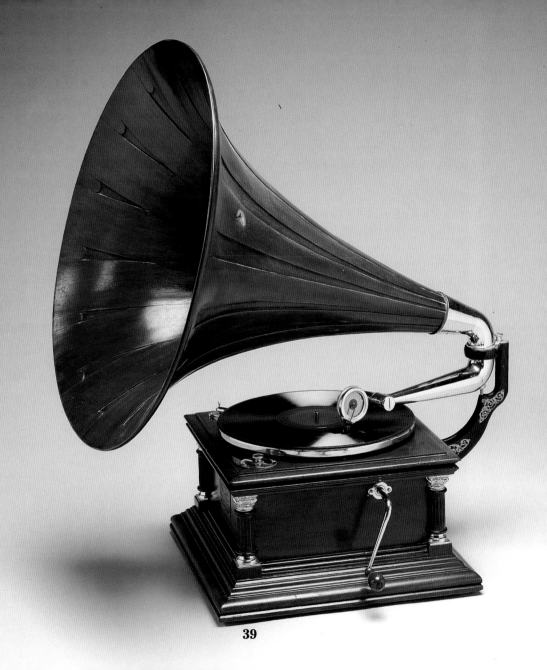

39

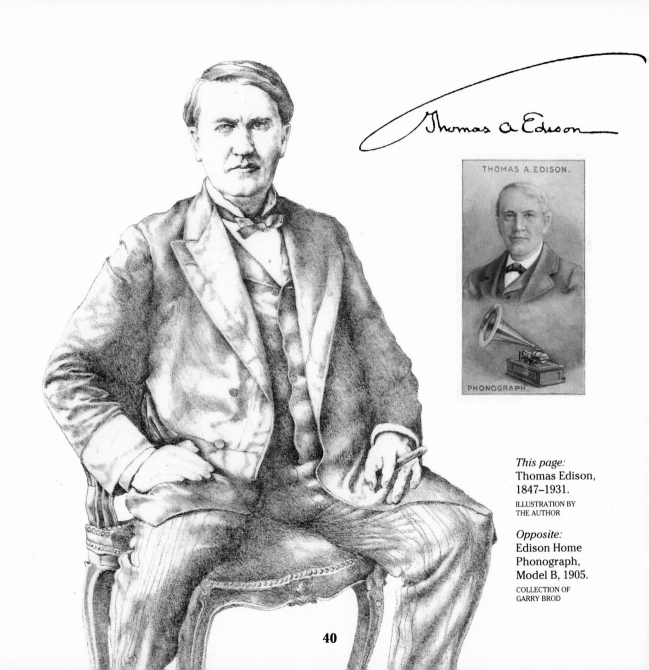

This page:
Thomas Edison,
1847–1931.

ILLUSTRATION BY
THE AUTHOR

Opposite:
Edison Home
Phonograph,
Model B, 1905.

COLLECTION OF
GARRY BROD

40

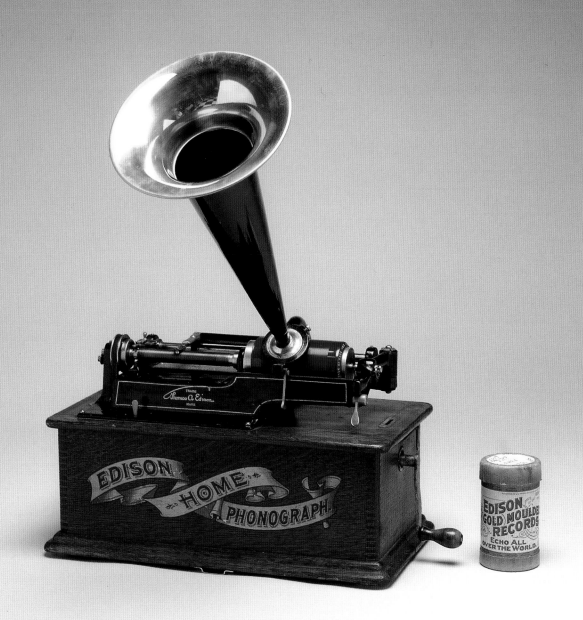

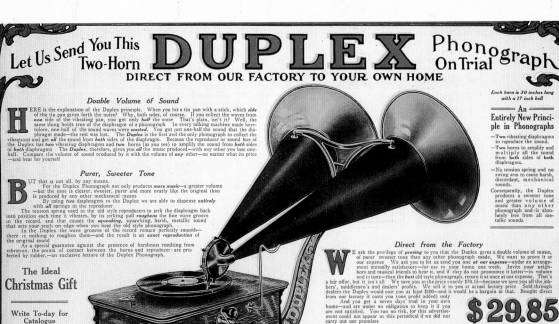

This twin-horned phonograph was a precursor of stereophonic sound, 1906.

COLLECTION OF KEITH CENEDELLA

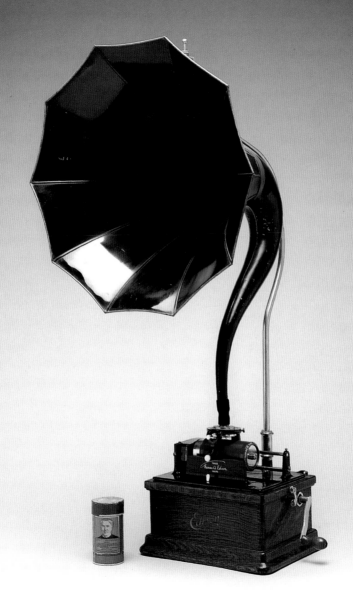

The Edison "Fireside"
Model A, 1909,
playing an Edison
Royal Purple
cylinder, circa 1918.
COLLECTION OF
LARRY DUNN

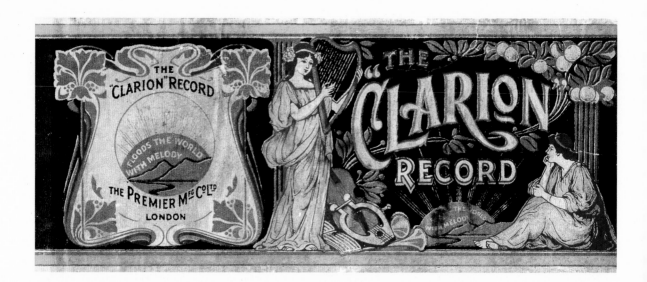

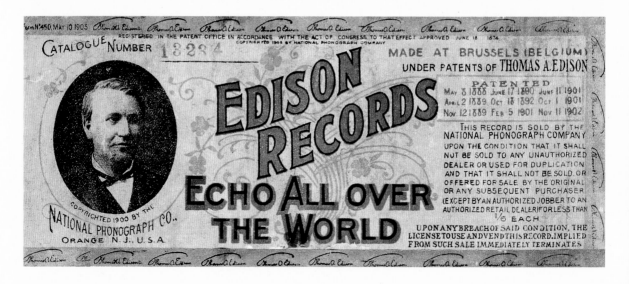

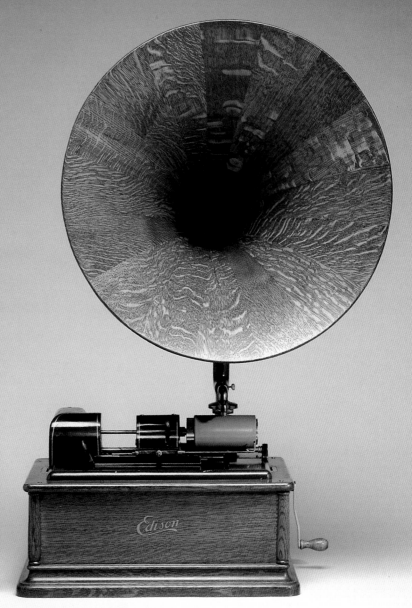

Opposite:
Phonograph cylinder
box labels. Edison
Records "Echo all
over the world"
while The Clarion
Record "Floods the
world with melody".

This page:
The Edison "Opera"
Phonograph, 1912.
COLLECTION OF
BILL FLAYER

45

POSTCARDS

The golden age of the Victrola coincided with the heyday of the postcard.

The popularity of the phonograph generated a proliferation of postcard images, as in these British World War I examples.

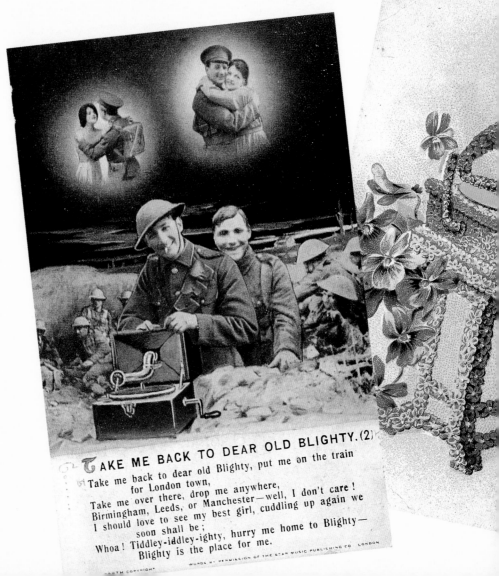

TAKE ME BACK TO DEAR OLD BLIGHTY. (2)

Take me back to dear old Blighty, put me on the train
for London town,
Take me over there, drop me anywhere,
Birmingham, Leeds, or Manchester—well, I don't care!
I should love to see my best girl, cuddling up again we
soon shall be ;
Whoa ! Tiddley-iddley-ighty, hurry me home to Blighty—
Blighty is the place for me.

WORDS BY PERMISSION OF THE STAR MUSIC PUBLISHING CO. LONDON

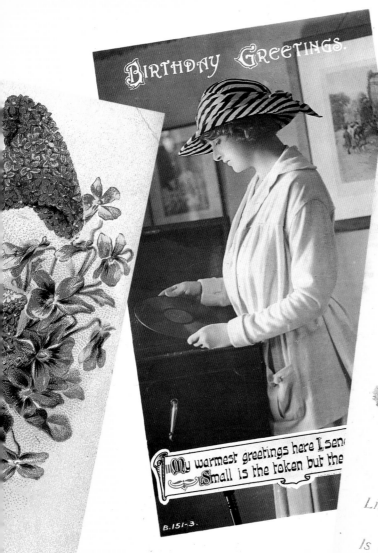

BIRTHDAY GREETINGS.

My warmest greetings here I send
Small is the token but the

B.151-3.

Birthday Greetings.

Like the tune of the records
so sweet and clear
Is the thought underlying
this greeting, Dear.

ADVERTISING

Much creativity went into the advertising and related collateral of the Victrola.

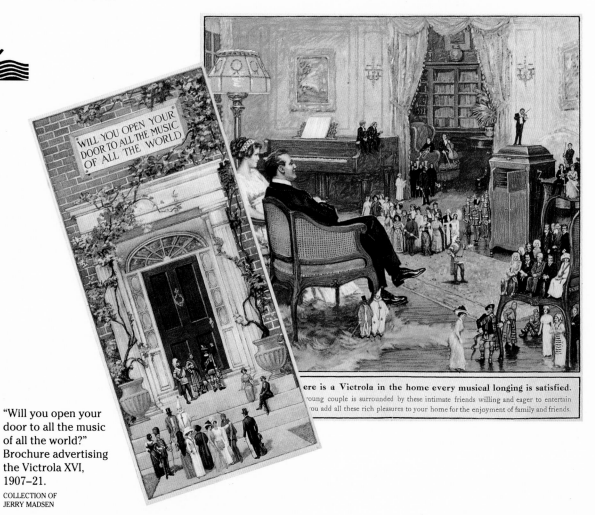

WILL YOU OPEN YOUR DOOR TO ALL THE MUSIC OF ALL THE WORLD

...ere is a Victrola in the home every musical longing is satisfied.
...oung couple is surrounded by these intimate friends willing and eager to entertain
...ou add all these rich pleasures to your home for the enjoyment of family and friends.

"Will you open your door to all the music of all the world?" Brochure advertising the Victrola XVI, 1907–21.

COLLECTION OF
JERRY MADSEN

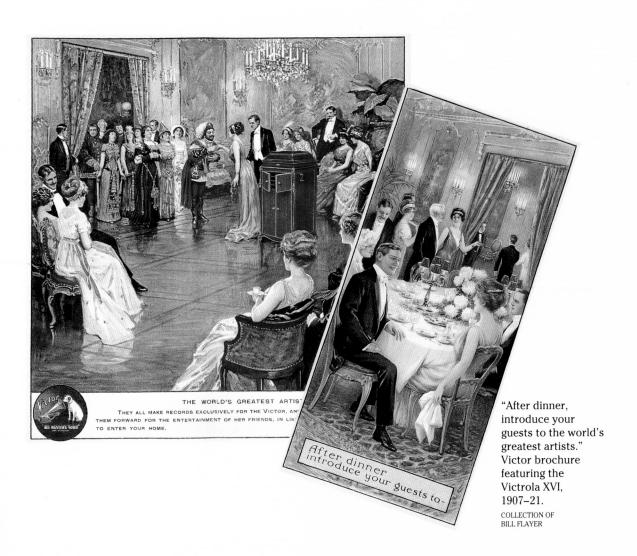

THE WORLD'S GREATEST ARTIST

THEY ALL MAKE RECORDS EXCLUSIVELY FOR THE VICTOR, AN[...]
THEM FORWARD FOR THE ENTERTAINMENT OF HER FRIENDS, IN LIK[...]
TO ENTER YOUR HOME.

After dinner, introduce your guests to.

"After dinner, introduce your guests to the world's greatest artists." Victor brochure featuring the Victrola XVI, 1907–21.

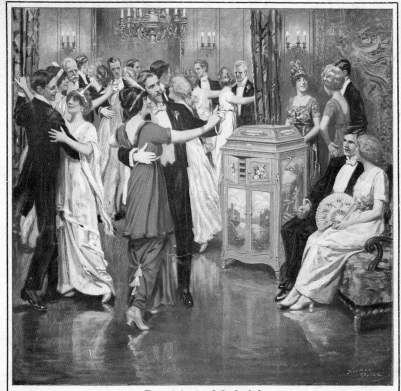

Dancing is delightful
to the music of the Victrola

Every one enjoys dancing to music of such splendid volume, such clearness and perfect rhythm and the Victrola plays as long as any one wants to dance.

The Victrola brings to you all kinds of music and entertainment, superbly rendered by the world's greatest artists who make records exclusively for the Victor.

Any Victor dealer will gladly play the latest dance music or any other music you wish to hear. There are Victors and Victrolas in great variety of styles from $10 to $200.

Victor Talking Machine Co., Camden, N. J., U. S. A.
Berliner Gramophone Co., Montreal, Canadian Distributors

This page:
An advertisement for a custom-made hand-painted Victrola cabinet, 1914.
COLLECTION OF BILL FLAYER

Opposite:
The Victor XXV, known as the "Schoolhouse Victor", 1913–25.
COLLECTION OF JOE URBANOVITCH

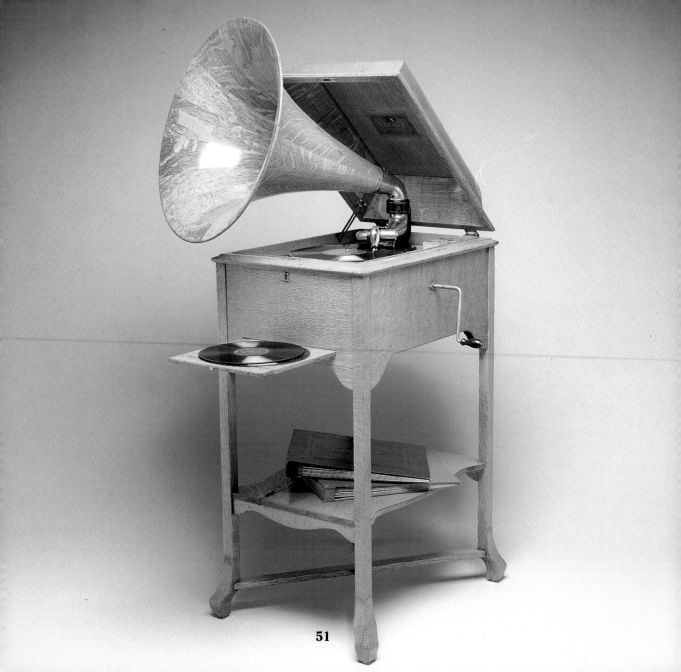

51

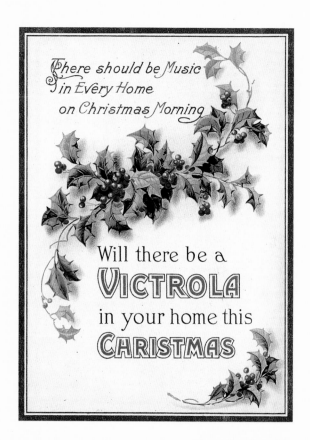

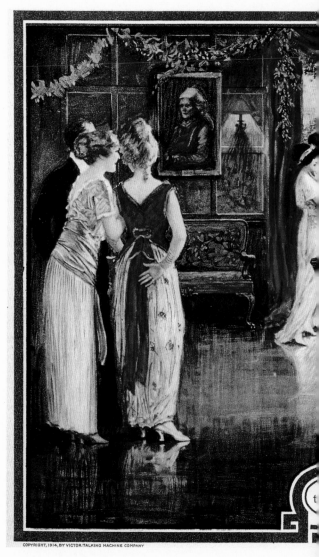

"There should be
music in every home
on Christmas
morning."
1914 brochure
advertising the
Victrola XVI,
1907–21.

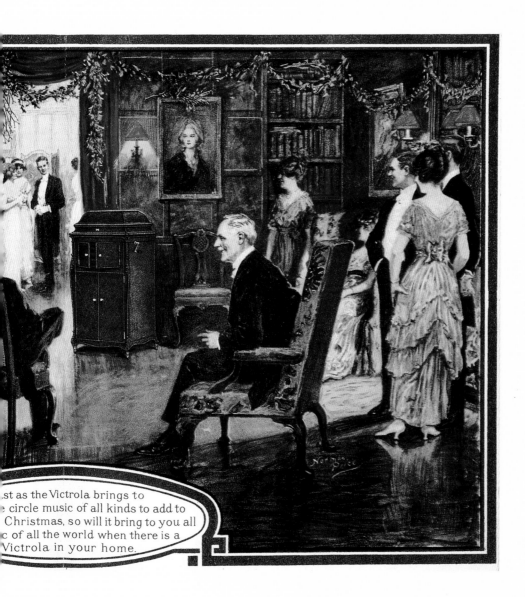

...st as the Victrola brings to
...e circle music of all kinds to add to
... Christmas, so will it bring to you all
... of all the world when there is a
... Victrola in your home.

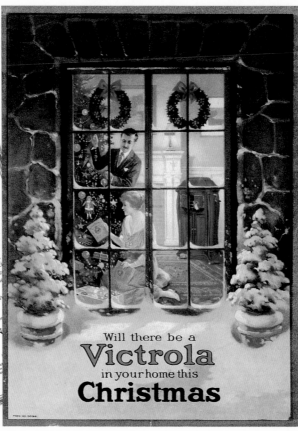

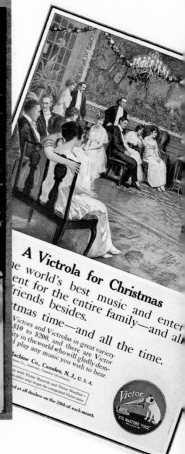

Press advertisement
for the Victrola XVIII,
1915-16.

Brochure advertising
the Victrola XVIII,
1915-16.

Press advertisement,
1914, promoting the
Victrola XVI, 1907-21.

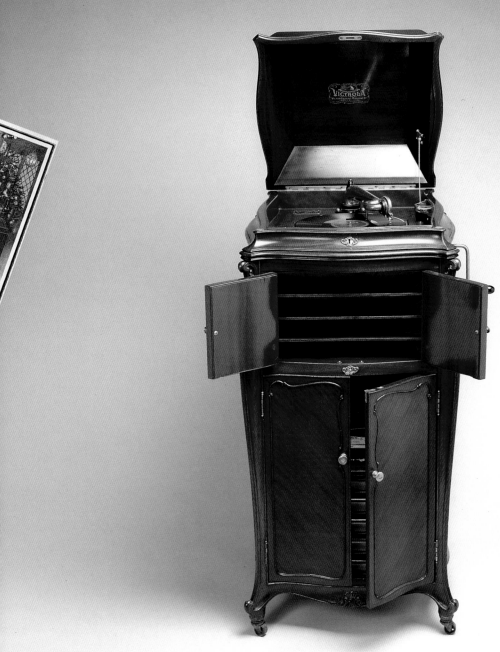

The Victrola XVIII, 1915–16. This machine was Victor's top-of-the-line Victrola, and sold for around $400.

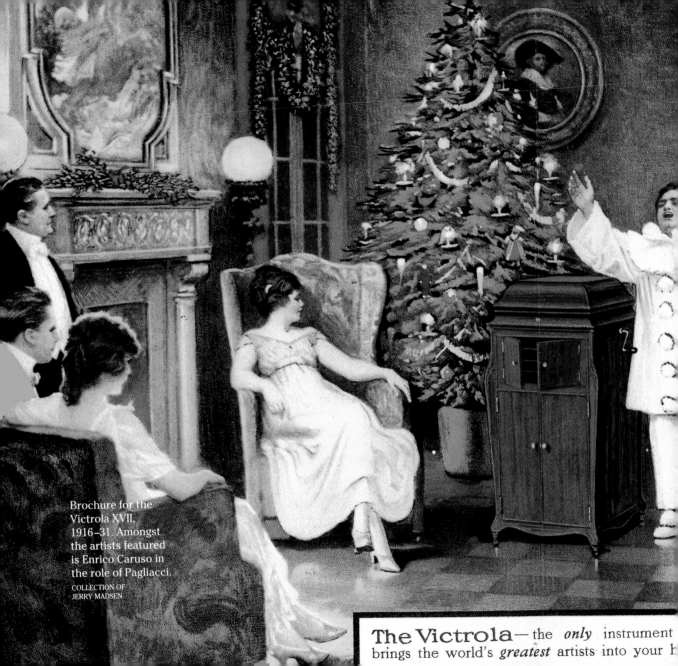

Brochure for the
Victrola XVII,
1916–31. Amongst
the artists featured
is Enrico Caruso in
the role of Pagliacci.

The Victrola— the *only* instrument
brings the world's *greatest* artists into your h

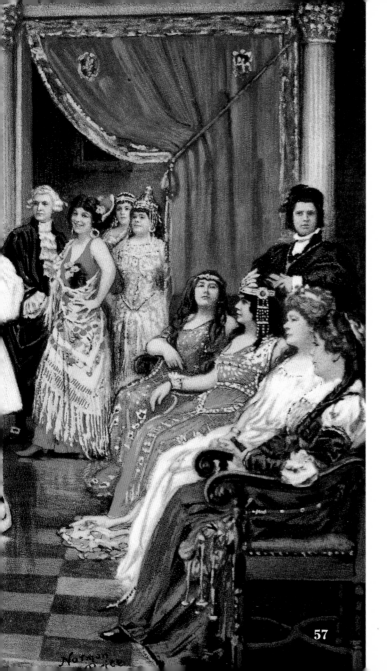

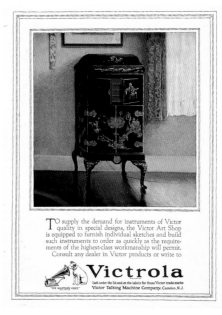

Above:
This magazine advertisement shows a black lacquer chinoiserie cabinet. Period Victrolas were produced between 1917 and 1925.

COLLECTION OF
BILL FLAYER

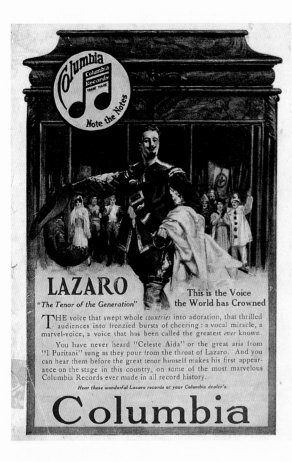

Columbia Records
advertisement
features Lazaro, 1916.

COLLECTION OF
BILL FLAYER

Columbia Grafonola
advertisement shows
a Reproducer, 1917.

COLLECTION OF
BILL FLAYER

Opposite:
Gramophone
reproducers.

COLLECTION OF
JOE URBANOVITCH

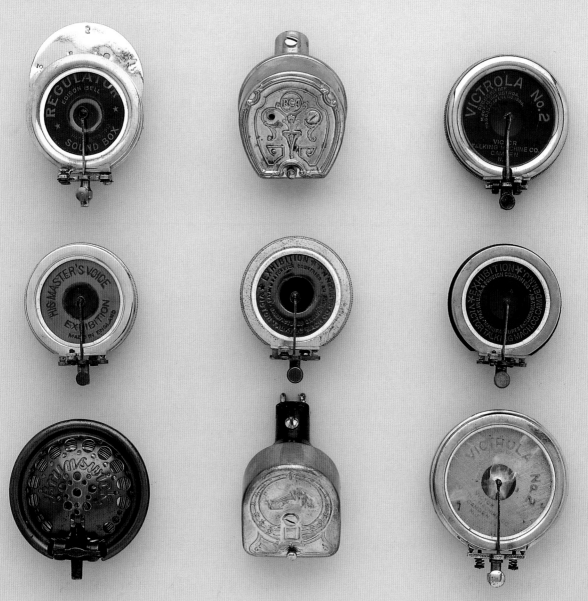

COLUMBIA

RECORDS Double-Disc

E VERYBODY joins in when the Columbia Grafonola plays the big
song hits of the day.

But the latest "hits," *first* recorded and *best* recorded on Columbia
Double-Disc Records, are only an indication, a foretaste of the life, the
fun, the sentiment, the classic beauty offered in the complete cata-
logue of Columbia Records, free on request at your dealer's.

New Columbia Records on Sale the 20th of every month

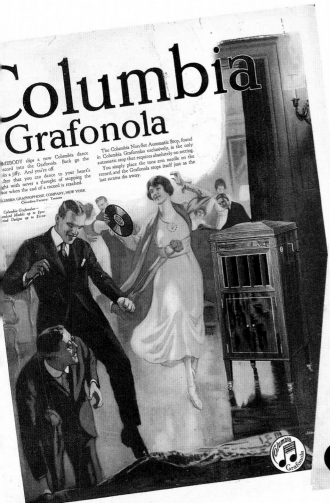
 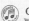

Soldiers advance
with fixed bayonets,
melding into peace-
time dancing couple
in this World War I
advertisement.
Footnote reads:
"Food will win the
war. Don't waste it.",
July 1918.

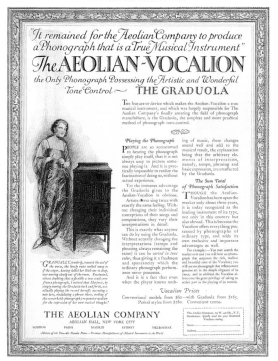

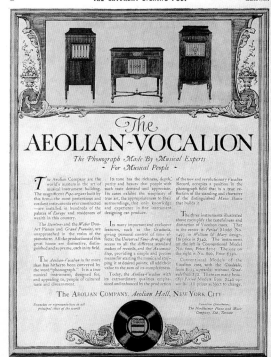

Aeolian-Vocalion
advertisements
show the Graduola
model with its
unique tone control,
and three William
and Mary–style
cabinets, 1919.

63

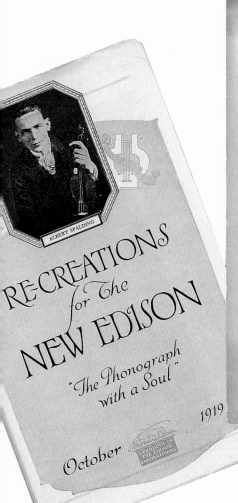

RE-CREATIONS
for The
NEW EDISON

"The Phonograph
with a Soul"

October 1919

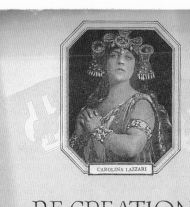

RE-CREATIONS
for The
NEW EDISON

"The Phonograph
with a Soul"
―
November 1919

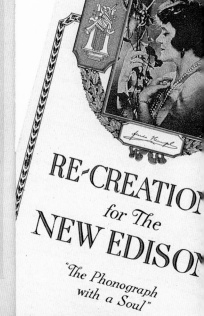

RE-CREATION
for The
NEW EDISON

"The Phonograph
with a Soul"

Edison Phonograph
catalogues, October
to December, 1919.

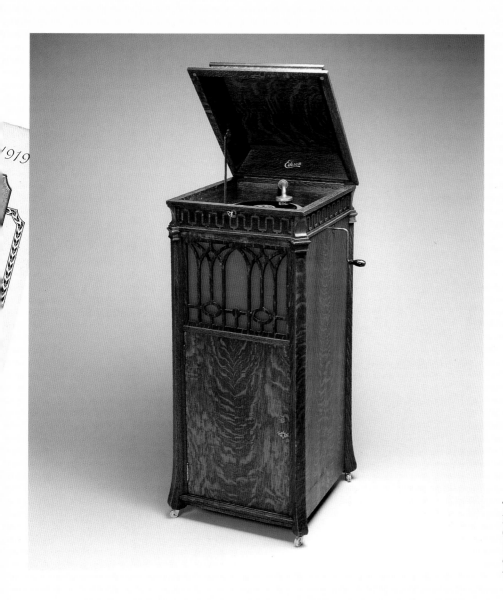

The Edison
Diamond Disc
Chippendale C/250,
1915–19.
COLLECTION OF
JOE URBANOVITCH

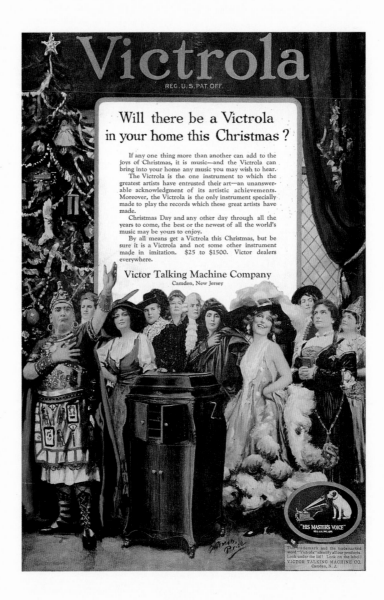

Victrola brings
out its stars for
Christmas in this
advertisement for
the Victrola No. 130,
1921–24.

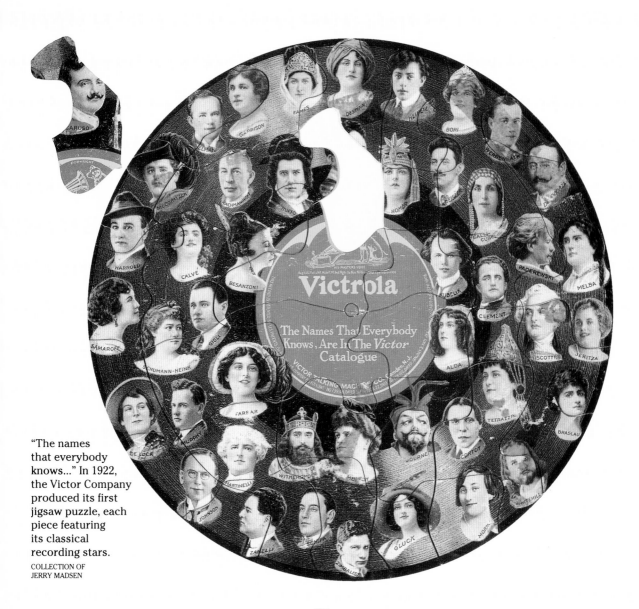

"The names that everybody knows..." In 1922, the Victor Company produced its first jigsaw puzzle, each piece featuring its classical recording stars.

COLLECTION OF
JERRY MADSEN

RECORD LABELS AND SLEEVES

The phonograph disc brought about a profusion of decorative record label and sleeve designs.

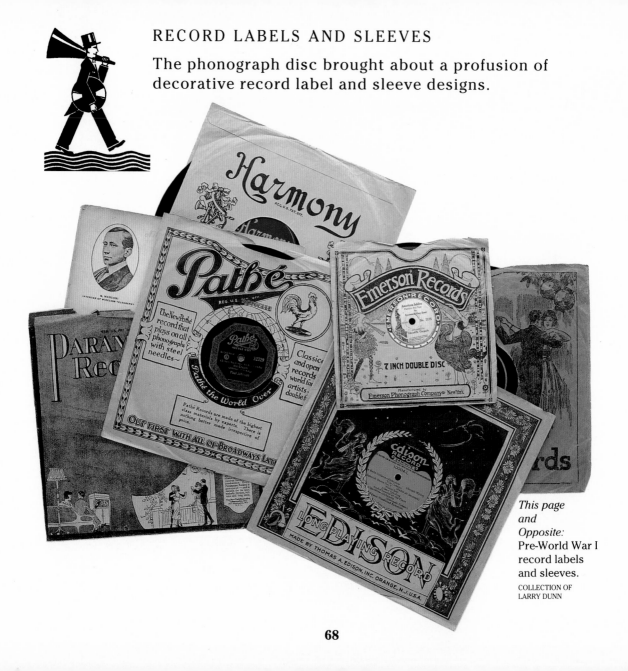

This page and Opposite: Pre-World War I record labels and sleeves.

COLLECTION OF LARRY DUNN

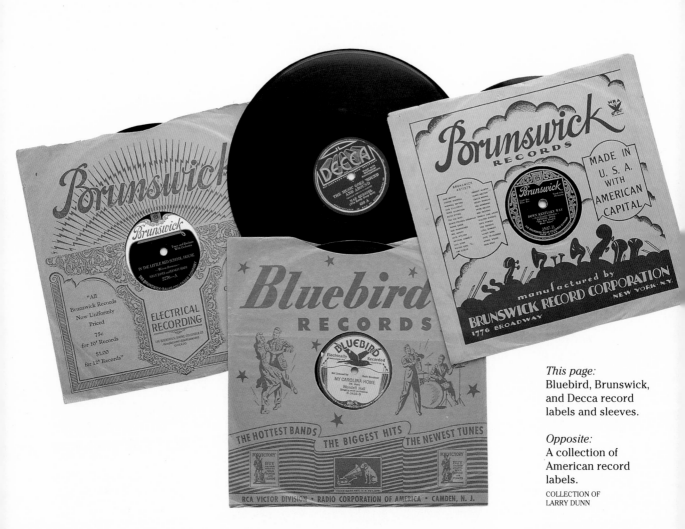

This page:
Bluebird, Brunswick, and Decca record labels and sleeves.

Opposite:
A collection of American record labels.

PHONOGRAPH NEEDLE TINS

Phonograph needles, "to be used once only", came in a variety of decorative containers.

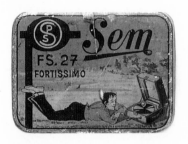 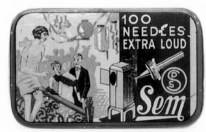 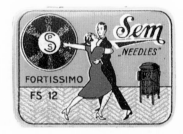

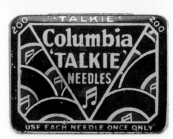

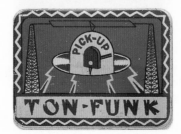

Above:
The illustrations on these Czechoslovakian tins are a souvenir from bygone carefree days.

Right:
The Columbia 'Talkie' and Ton-Funk Pick-Up tins are fine examples of the Art Deco period of design.

COLLECTION OF THE AUTHOR

Opposite:
Phonograph needle containers came in many shapes and materials, including bamboo, cardboard leather, mother-of-pearl, steel, tin, tortoise shell, and wood. Pyramid and bell-shaped tins dispensed one needle at a time from their apex. Some record polishers could be used to store needles.

COLLECTION OF THE AUTHOR

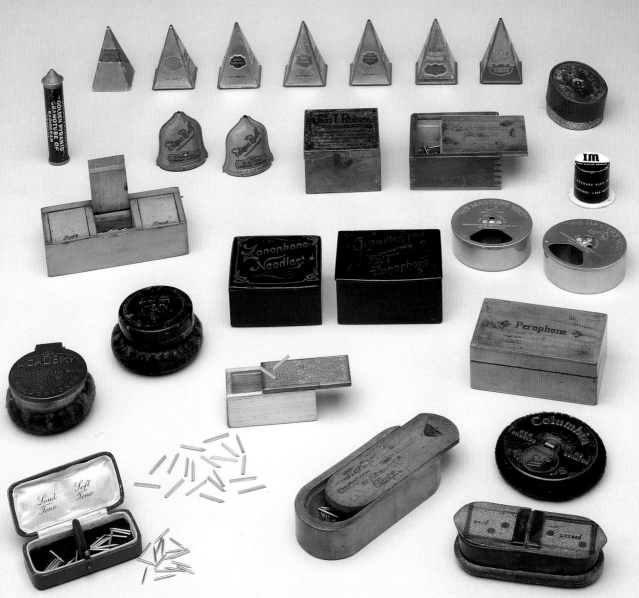

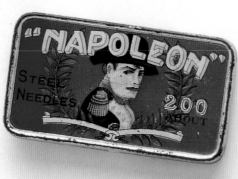

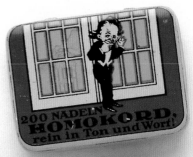

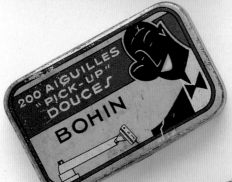

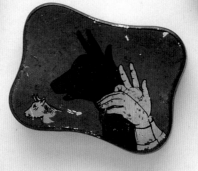

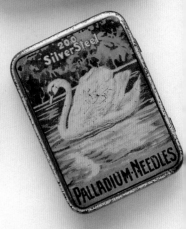

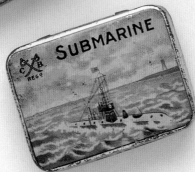

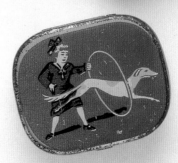

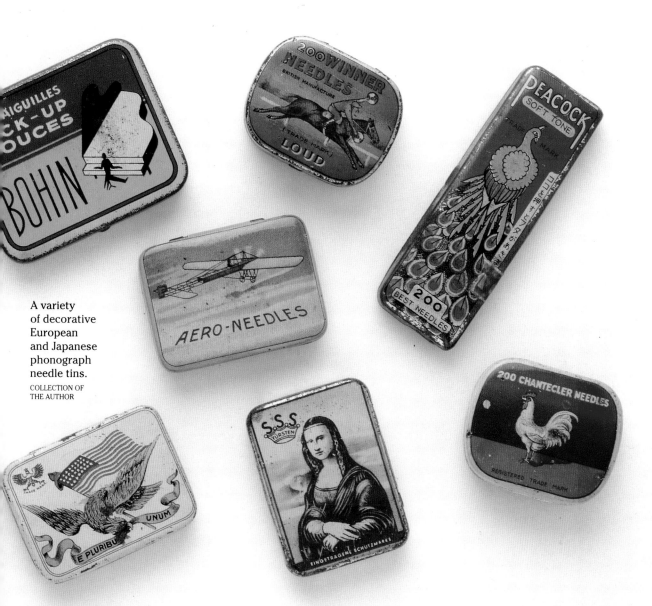

A variety of decorative European and Japanese phonograph needle tins.

COLLECTION OF THE AUTHOR

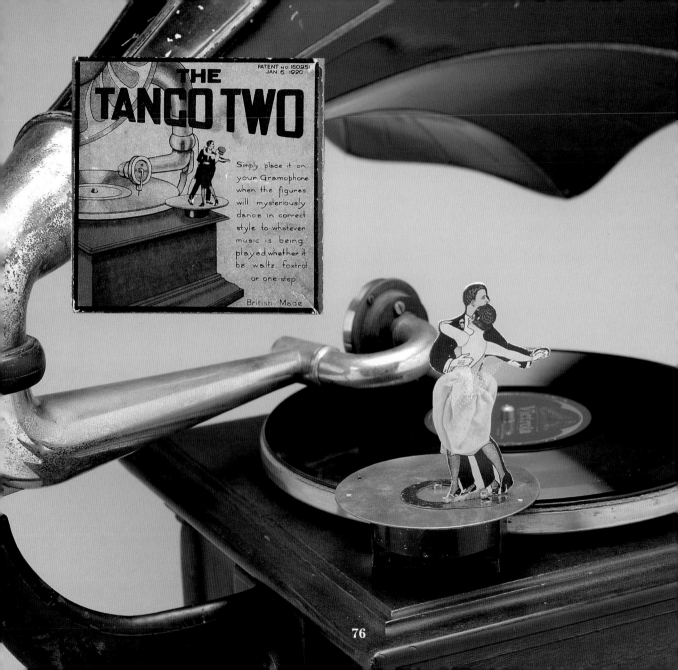

PATENT No 160951
JAN. 6. 1920

THE TANGO TWO

Simply place it on
your Gramophone
when the figures
will mysteriously
dance in correct
style to whatever
music is being
played, whether it
be waltz, foxtrot
or one-step

British Made

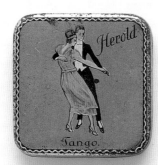
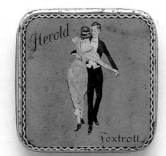

Opposite:
"The Tango Two", a unique accessory which could be easily attached to the edge of a record, and with a variety of templates, the figures performed different dance steps, such as the Waltz, Fox Trot or One Step. British, 1920.

COLLECTION OF
THE AUTHOR

This page:
A set of German phonograph needle tins featuring the popular dance steps of the day.

COLLECTION OF
THE AUTHOR

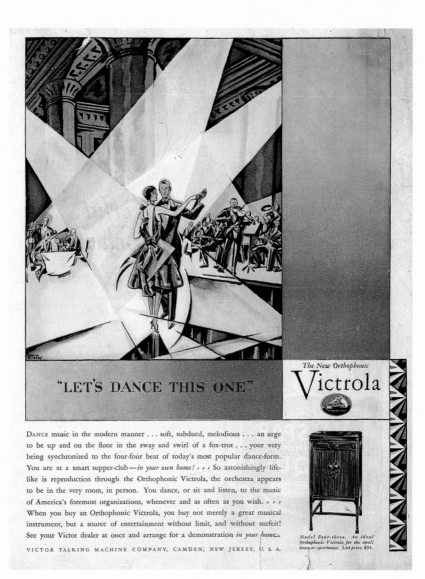

"LET'S DANCE THIS ONE"

The New Orthophonic

Victrola

DANCE music in the modern manner . . . soft, subdued, melodious . . . an urge to be up and on the floor in the sway and swirl of a fox-trot . . . your very being synchronized to the four-four beat of today's most popular dance-form. You are at a smart supper-club — *in your own home! . . .* So astonishingly life-like is reproduction through the Orthophonic Victrola, the orchestra appears to be in the very room, in person. You dance, or sit and listen, to the music of America's foremost organizations, whenever and as often as you wish. . . . When you buy an Orthophonic Victrola, you buy not merely a great musical instrument, but a source of entertainment without limit, and without surfeit! See your Victor dealer at once and arrange for a demonstration *in your home.*

VICTOR TALKING MACHINE COMPANY, CAMDEN, NEW JERSEY, U. S. A.

Model Four-three. An ideal Orthophonic Victrola for the small home or apartment. List price, $95.

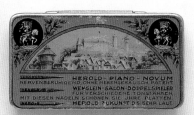

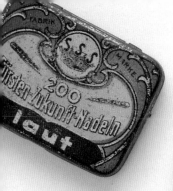

200
Fürsten-Zukunft-Nadeln
laut

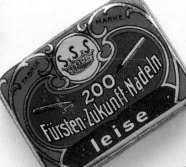

S.S.S.
MARKE.
FABRIK
200
Fürsten-Zukunft-Nadeln
leise

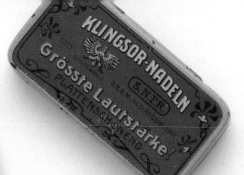

KLINGSOR-NADELN
S.N.E.R.
Grösste Lautstärke!
PLATTENSCHONEND

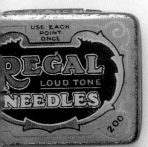

USE EACH
POINT
ONCE
REGAL
LOUD TONE
NEEDLES
200

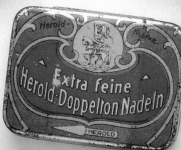

Herold-
Marke.
Extra feine
Herold-Doppelton Nadeln
HEROLD

REGISTERED
200
ODE
NEEDLES
SEE

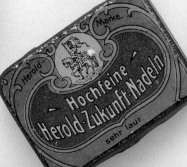

Marke.
Herold-
Hochfeine
Herold-Zukunft-Nadeln
sehr laut

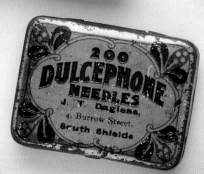

200
DULCEPHONE
NEEDLES
J. V. Daglens,
4, Burrow Street,
South Shields

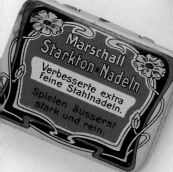

Marschall
Starkton-Nadeln
Verbesserte extra
feine Stahlnadeln.
Spielen äusserst
stark und rein.

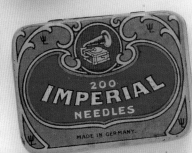

200
IMPERIAL
NEEDLES
MADE IN GERMANY

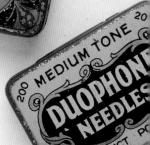

200 MEDIUM TONE
20
DUOPHON
NEEDLES
FECT. P

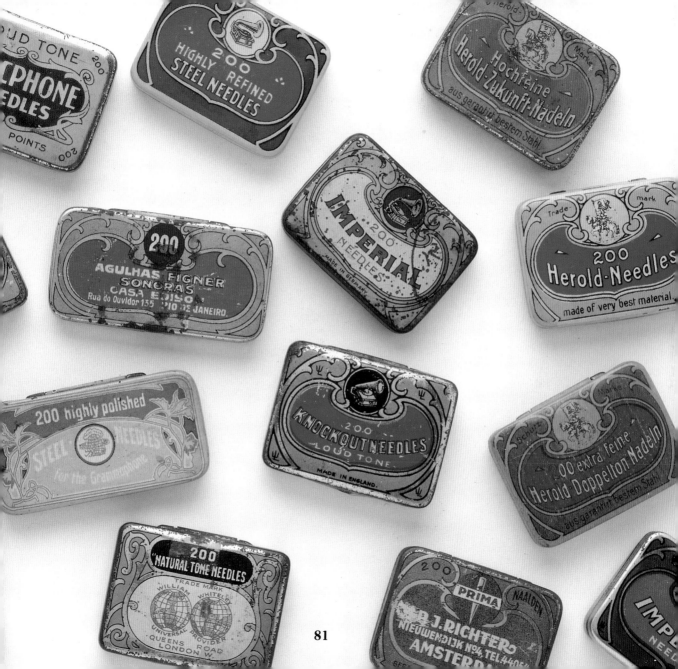

The NEW PORTABLE VICTROLA

HAS BIGGER TONE ... BETTER APPEARANCE ... AND MORE CONVENIENCES

It Is An Ideal Home Entertainer

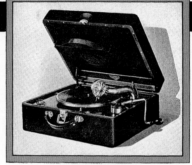

IN TWO STYLES

PORTABLE VICTROLA NO. 2-55

List price: **$35.00**

Red Python-skin Fabrikoid . . . or Padded Blue Fabrikoid

ANOTHER PORTABLE VICTROLA MODEL IS NO. 2-35, LIST PRICE $25.00
A MARVELOUS LITTLE PERFORMER

WHERE FLOOR SPACE IS VALUABLE

Quality ENTERTAINMENT IS ASSURED WITH

THE PORTABLE VICTROLA

DESIGNERS of furniture and other home equipment are now completely recognizing the fact that the modern small home and apartment demand "Luxury in Miniature." People enjoy the carefree comfort of the apartment, but do not wish its lack of floor space to deprive them of pleasures easily within their means. Hence, the massive furniture of the Victorian period is giving place to the small, highly decorative, modern cabinetry. In such homes the new Portable Victrola has found itself a most apt entertainer. When not in use it stands in a corner, under a table, or in a closet . . . but in an instant it may be called upon to provide the dandiest fox trot or the most inspiring symphony. It is a "portable" in size only: In every respect it is a quality musical instrument, whose *Orthophonic Type Soundbox, Automatic Brake,* and easy *Angle-Wind* will give you all the fullness of tone and comfort of operation which you naturally expect from a Victor instrument. Thousands have found that it has—

VOLUME

WONDERFUL *for* DANCING

AT SCHOOL OR COLLEGE

GOOD FELLOWS GATHER IN THE ROOM WITH

THE PORTABLE VICTROLA

ANY boy or girl will tell you that music plays a big part in school and college life. That newest fox trot by Rudy Vallée . . . that marvelous Reisman waltz . . . Gene Austin's latest heart-winner . . . or Helen Kane's most recent comic baby-talk . . . such subjects are certain to rival in importance a theorem of Pythagoras or three pages of Virgil. Let the Geometry and the Latin stick to their study hours! When good fellows gather in the "dorm" it's *Portable Victrola Time!* This snappy little Victor entertainer gives the boys and girls some of their best sport. When they're with the Portable Victrola they're bound to be having a good time . . . and, incidentally, out of mischief! If you are a parent, sending a son or daughter to college . . . or if you are the "young 'un" who's getting together your campus outfit . . . don't forget the Portable Victrola. It's a real economy! It's so sturdy it'll easily last through school and college, and will have plenty of cheer left for the summers in between. Its good looks will appeal to you. Remember, you can get it in two colors . . .

The Red and the Blue PORTABLE VICTROLAS

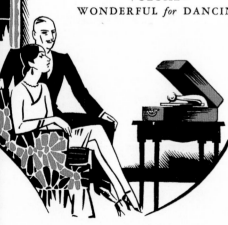

The Art Deco illustrations in this brochure demonstrate the versatility of the Portable Victrola No. 2–55, 1929.

COLLECTION OF
BILL FLAYER

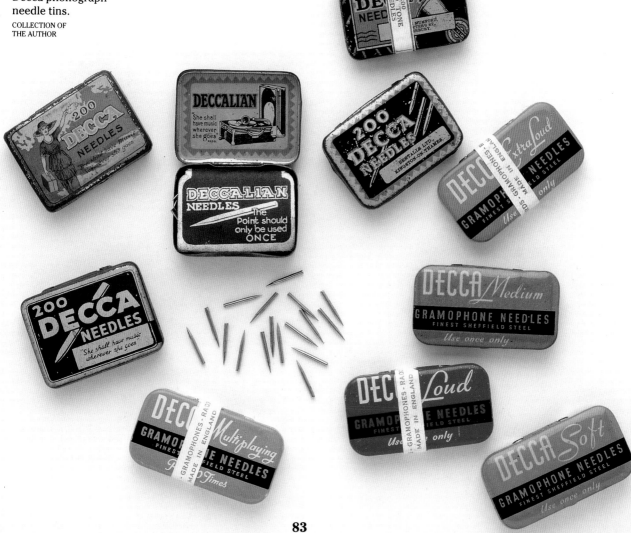

"She shall have music wherever she goes."
Decca phonograph needle tins.

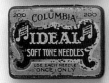
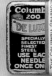

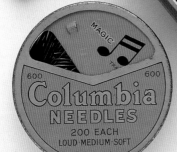
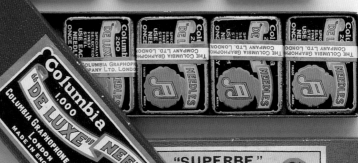

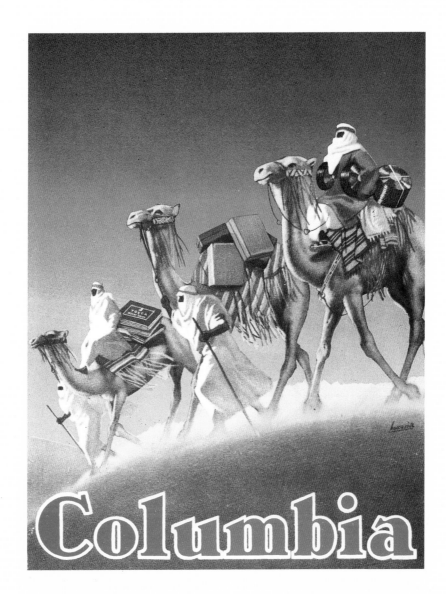

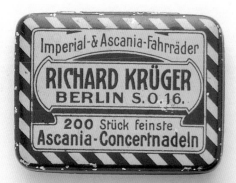

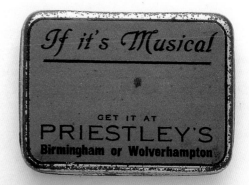

This page:
These personalized tins advertise dealers' stores in Germany, England, Austria, Holland, and Ireland. H.M.V. dealerships often provided their names and addresses on a decal inside the tin's lid.

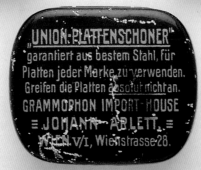

Opposite:
A range of Songster needle tins.

Pages 88/89:
Animals were a popular theme on European phonograph needle tins.

COLLECTION OF THE AUTHOR

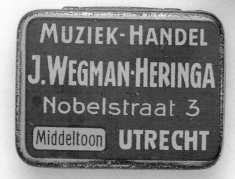

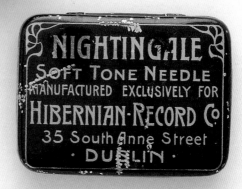

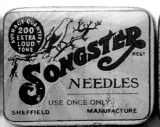

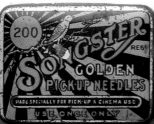

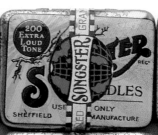

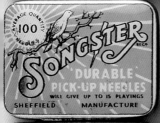

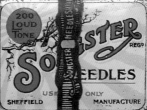

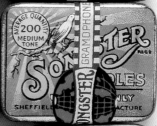

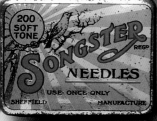

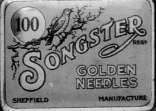

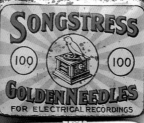

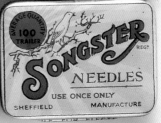

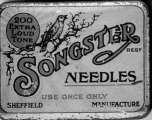

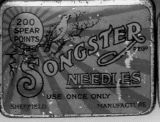

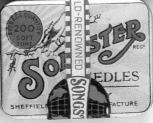

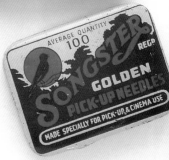

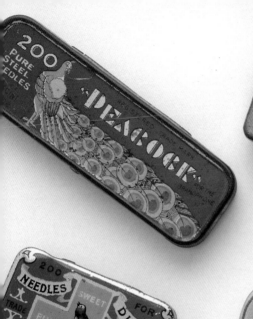

200 PURE STEEL NEEDLES · PEACOCK · REGISTERED TRADE MARK

DULCETTO NEEDLES LOUD TONE

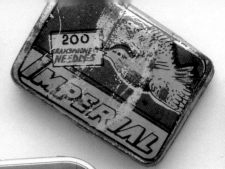

200 GRAMOPHONE NEEDLES IMPERIAL

TAHAPHONE EXTRA LOUD TONE

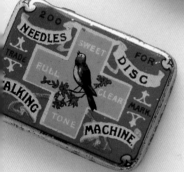

200 NEEDLES FOR SWEET DISC FULL CLEAR TRADE MARK TONE TALKING MACHINE

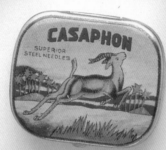

CASAPHON SUPERIOR STEEL NEEDLES

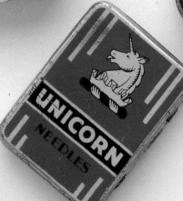

UNICORN NEEDLES

MEL TONE 200 FOR GRAMOPHONE

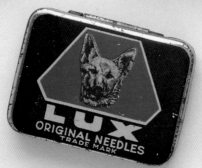

LUX ORIGINAL NEEDLES TRADE MARK

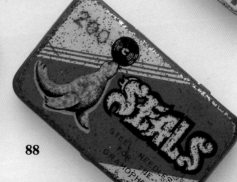

200 SEALS STEEL NEEDLES FOR THE GRAMOPHONE

HERO LOUD TONE NEEDLES MADE IN GERMANY

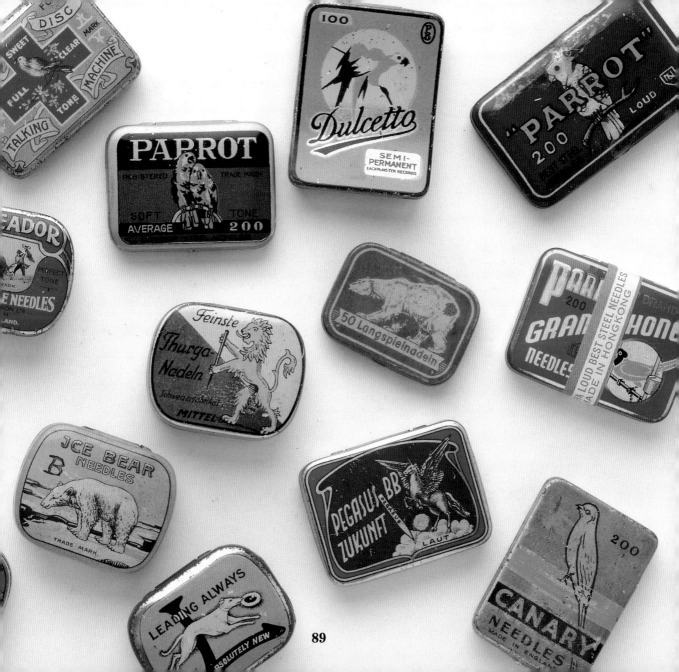

89

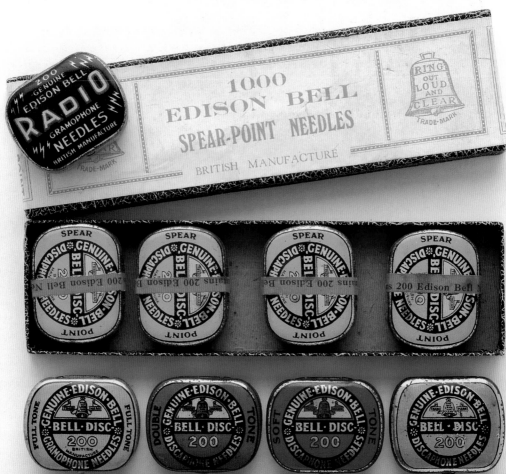

Opposite:
A variety of Edison Bell phonograph needle tins.

This page:
Japanese phonograph needle tins and paper seal give a French hero an Asian look.

Pages 92/93:
Examples of European needle tins.

COLLECTION OF THE AUTHOR

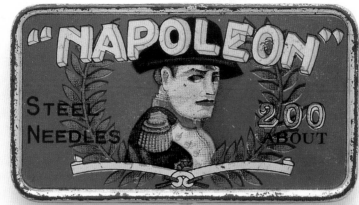

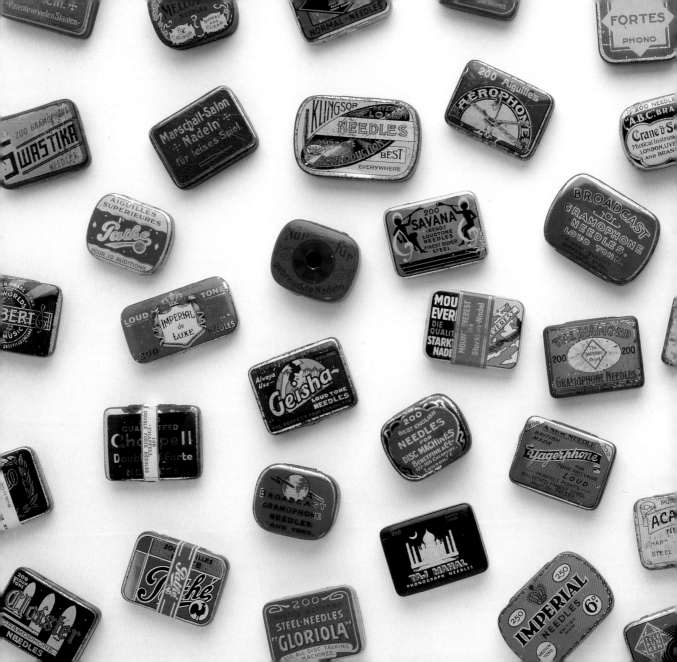

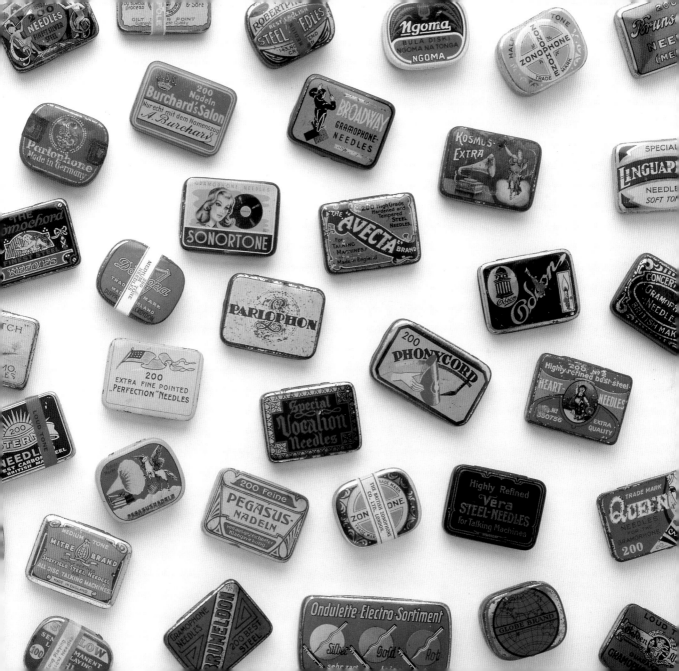

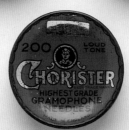

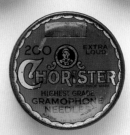

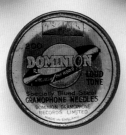

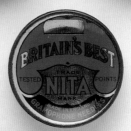

Phonograph needle tins came in many different shapes and sizes, however, the majority are rectangular and measure approximately one-and-a-half by two inches and contain two hundred needles "to be used once only".

COLLECTION OF
THE AUTHOR

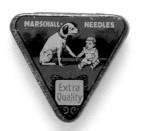
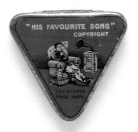

These oblong compartmentalized tins held a choice of needles from soft to extra loud. The diameter and length of each needle controlled the volume—the thicker the needle, the louder the sound.

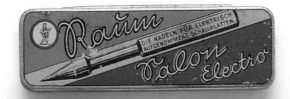

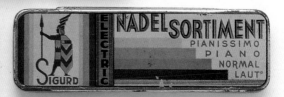

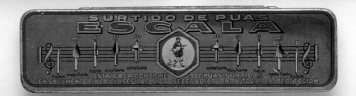

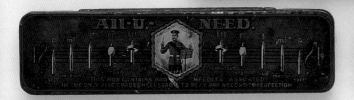

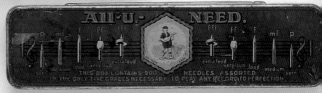

Patriotic British themes were prevalent during World War I, as illustrated on these phonograph needle tins.

COLLECTION OF THE AUTHOR

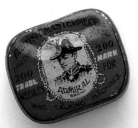
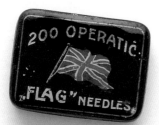
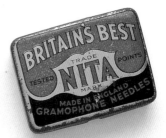
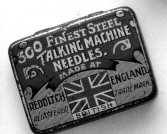
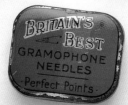
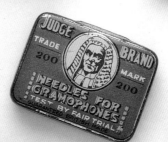
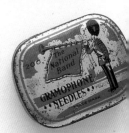
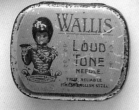
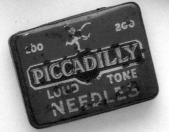
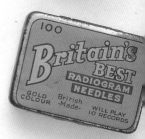
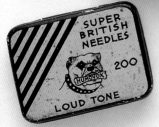
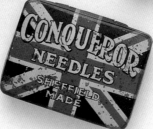
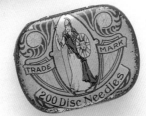

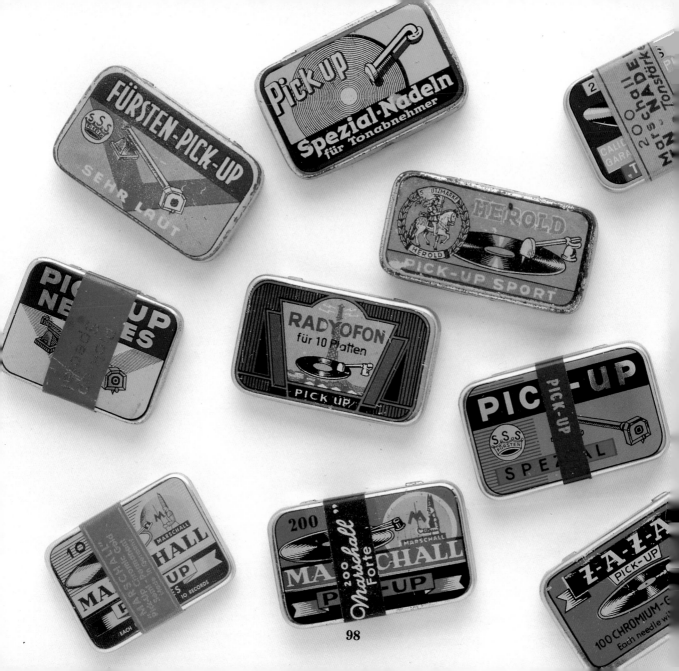

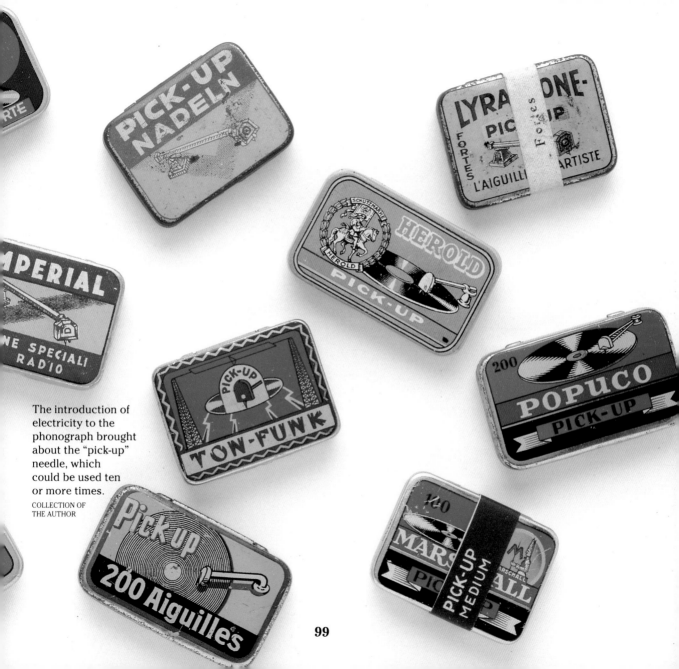

The introduction of electricity to the phonograph brought about the "pick-up" needle, which could be used ten or more times.
COLLECTION OF THE AUTHOR

99

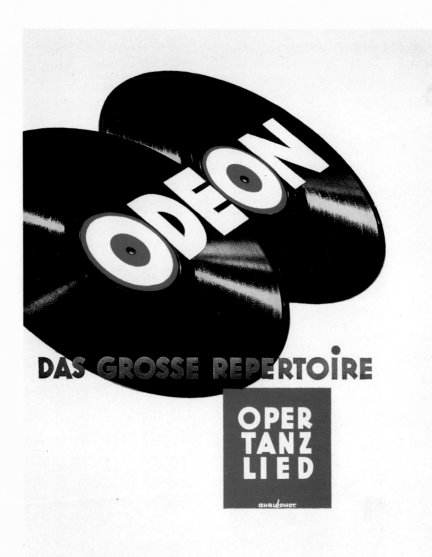

ODEON
DAS GROSSE REPERTOIRE

OPER
TANZ
LIED

This page:
A German poster
for Odeon Records,
1929.

Opposite:
The invention
of Bakelite by
Dr. Leo Baekeland
in 1906 made
available a new
material for the
containers of
phonograph needles.
Note the Argentinian
container shaped
like a grand piano.

Pages 102/103:
The needle tin
was essentially
a European
phenomenon, as in
the United States
phonograph needles
were usually sold in
paper packets.
COLLECTION OF
THE AUTHOR

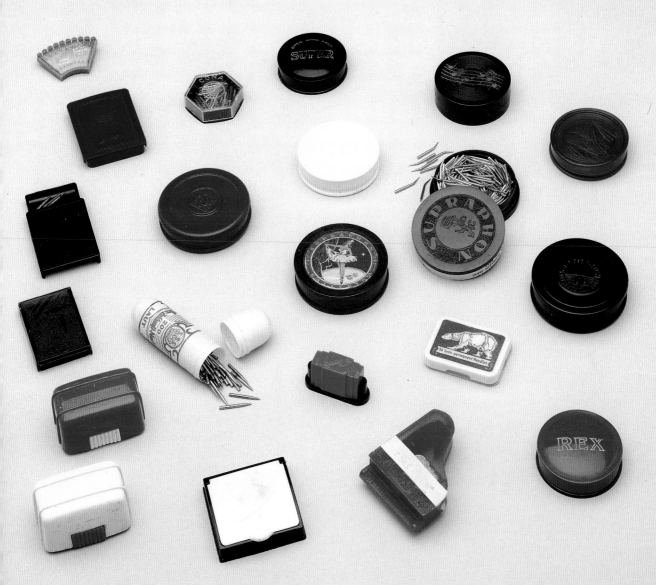

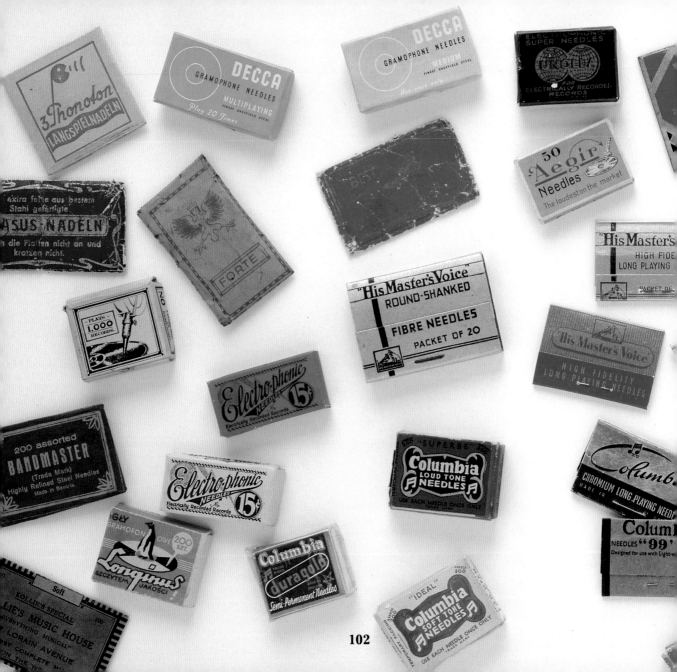

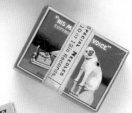
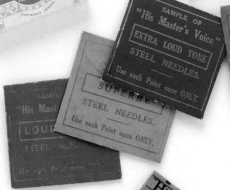

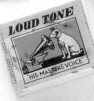

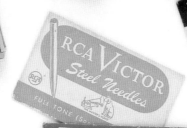

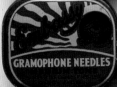
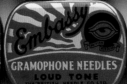
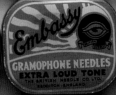
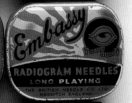

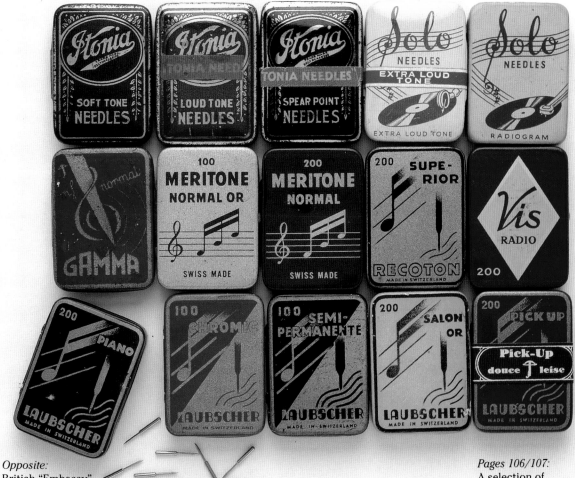

Opposite:
British "Embassy"
phonograph
needle tins.

This page:
Swiss needle tins.

Pages 106/107:
A selection of
phonograph
needle tins.
COLLECTION OF
THE AUTHOR

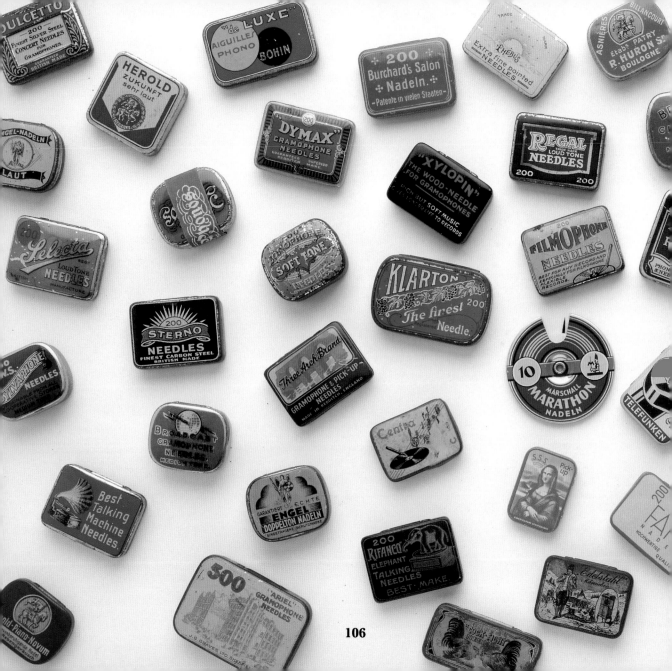

106

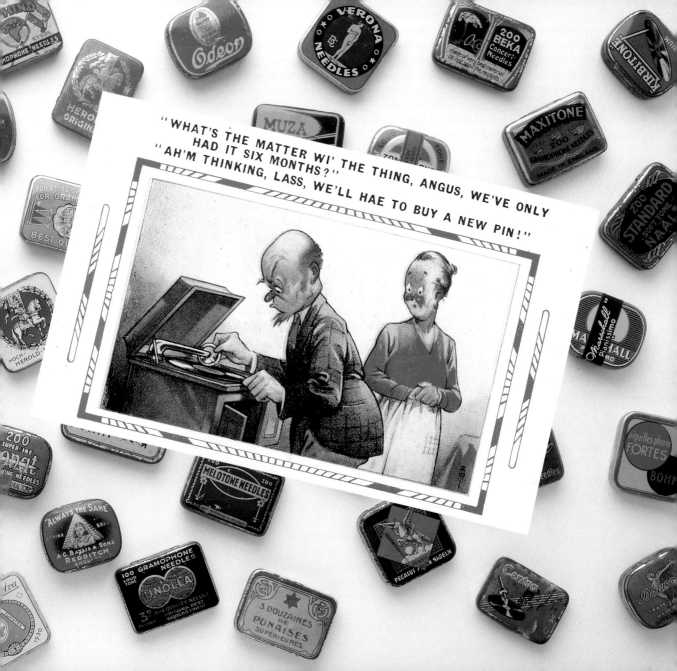

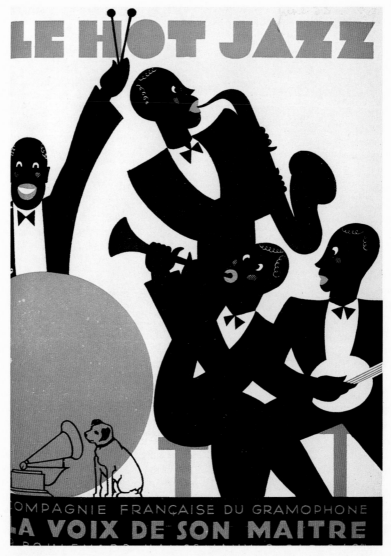

This page:
The Art Deco period,
or Jazz Age, reached
its zenith during the
late 20's and early
30's, as exemplified in
this French "La Voix
de Son Maitre"
("His Master's Voice")
catalog cover, 1939.

Opposite:
Butterfly shaped
phonograph
needle tins.

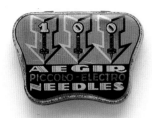

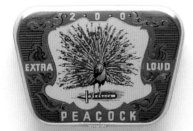

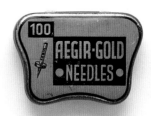

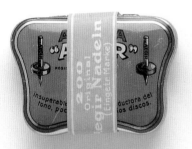

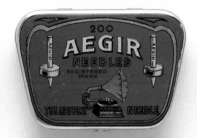

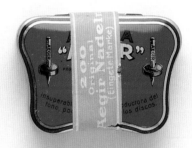

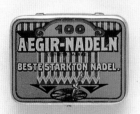

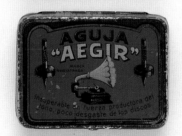

PICTURE RECORDS

The introduction of flexible vinyl records brought with it a new medium for the commercial artist.

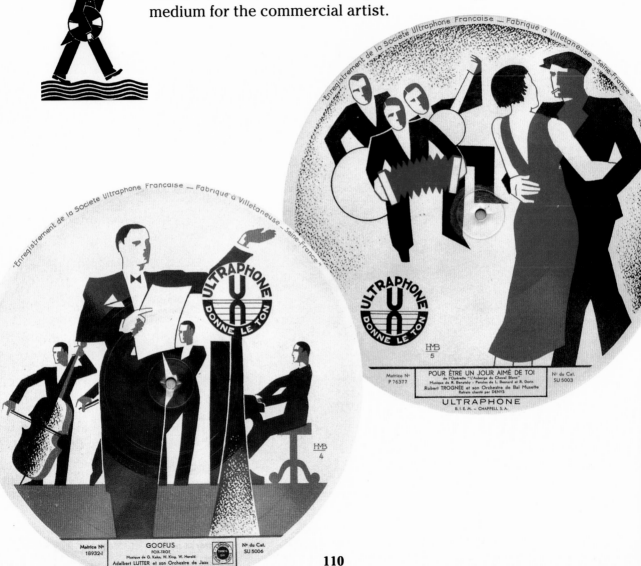

Art Deco style
illustrations cover
the complete surface
of these French
Ultraphone picture
records, 1930's.

COLLECTION OF
MARTIN AND JILLIANA
RANICOR-BREEZE

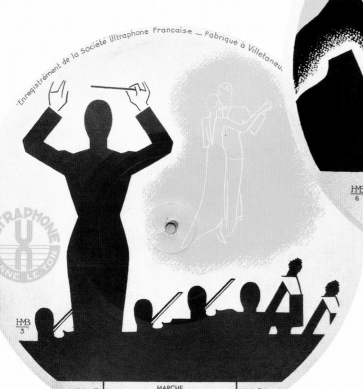

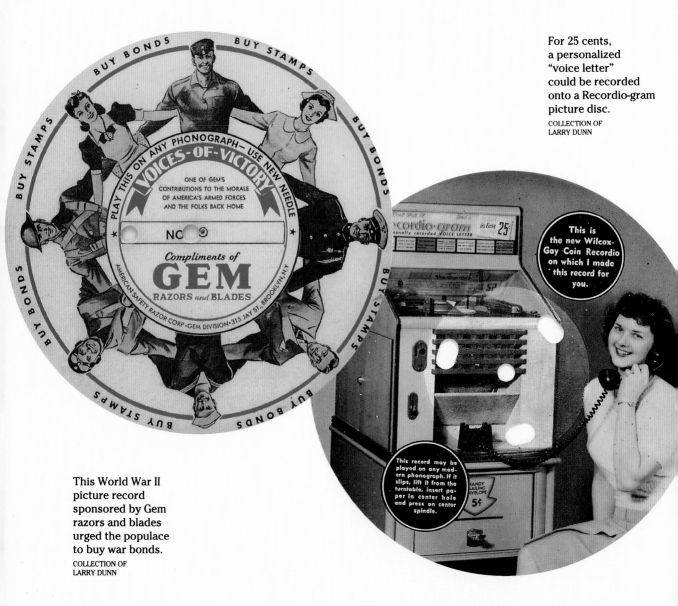

For 25 cents, a personalized "voice letter" could be recorded onto a Recordio-gram picture disc.
COLLECTION OF LARRY DUNN

This World War II picture record sponsored by Gem razors and blades urged the populace to buy war bonds.
COLLECTION OF LARRY DUNN

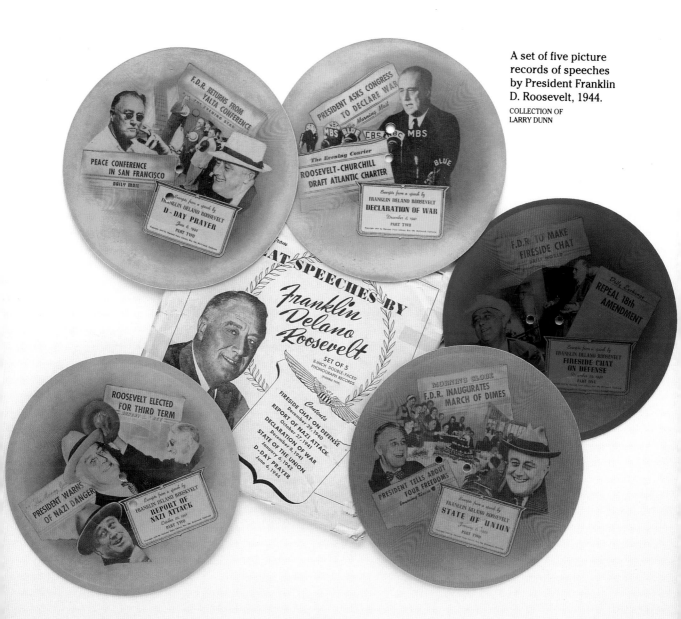

A set of five picture records of speeches by President Franklin D. Roosevelt, 1944.

COLLECTION OF
LARRY DUNN

Obverse and reverse
sides of a Vogue
picture record, 1946.

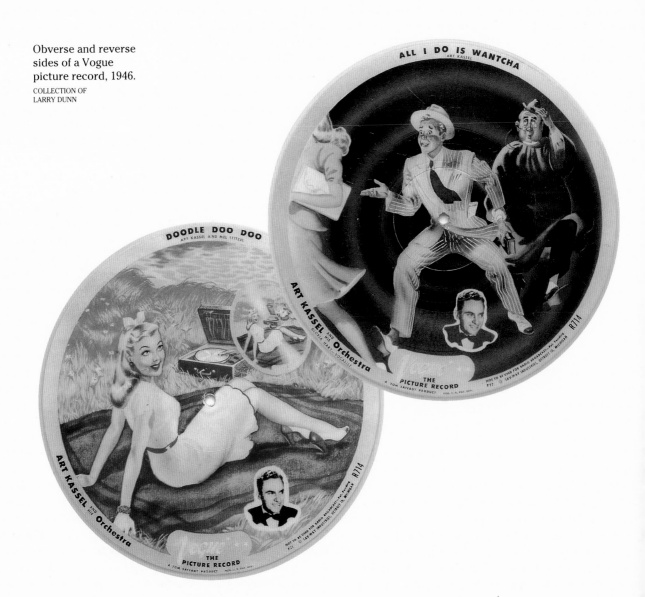

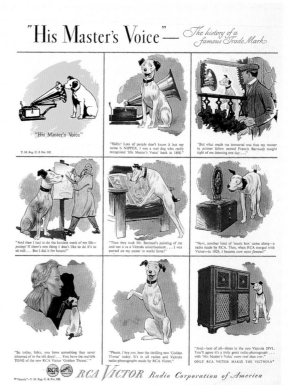

Two RCA Victor
advertisements
bring "Nipper"
back to the fore.
Left: Victrola 65U.
Right: Victrola 59VI.

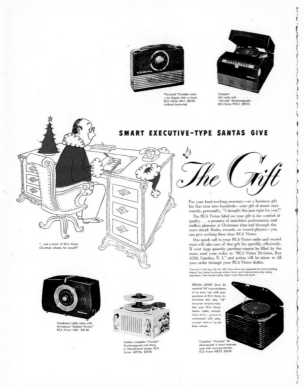

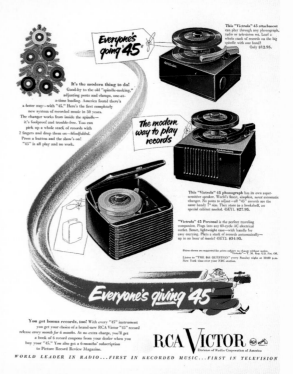

Advertisement for a range of RCA Victor phonographs, including the Kiddies' Complete "Victrola" with "Alice-in-Wonderland" design, RCA Victor 45EY26.

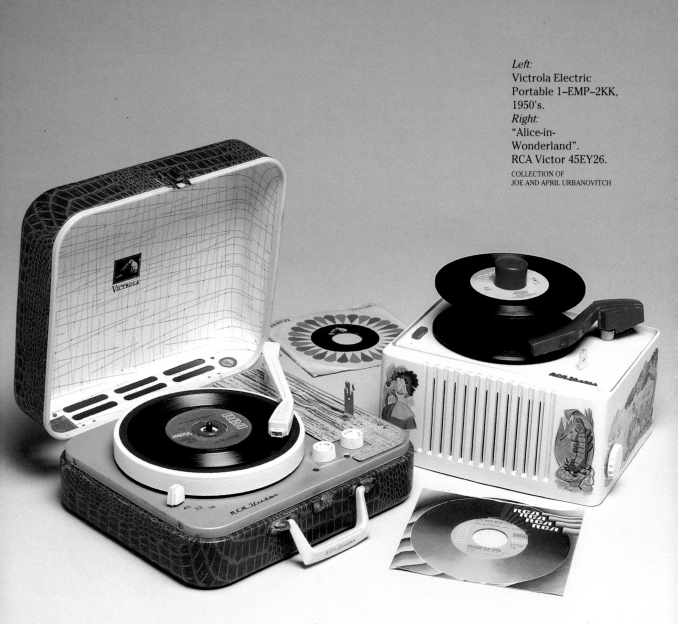

Left:
Victrola Electric
Portable 1–EMP–2KK,
1950's.
Right:
"Alice-in-
Wonderland".
RCA Victor 45EY26.
COLLECTION OF
JOE AND APRIL URBANOVITCH

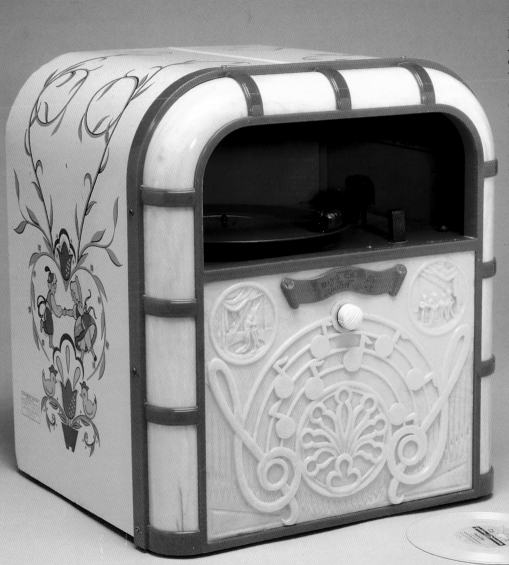

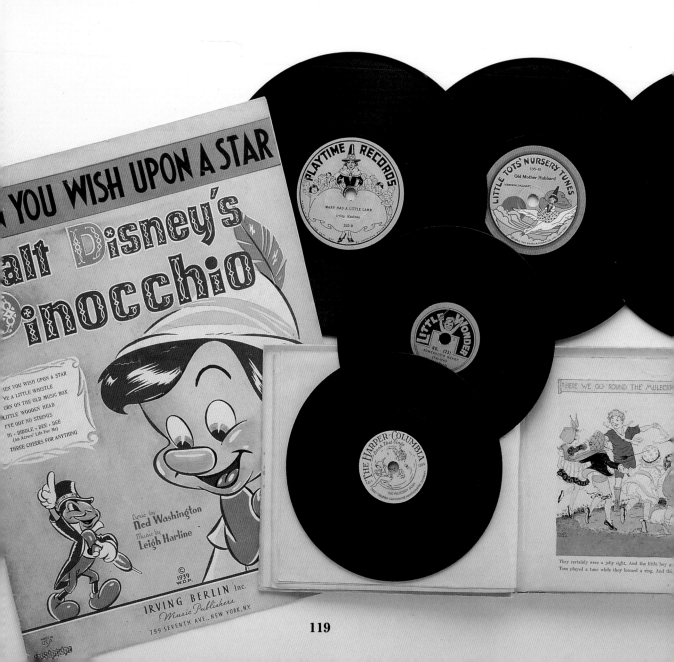